Figure
Drawing
Workshop

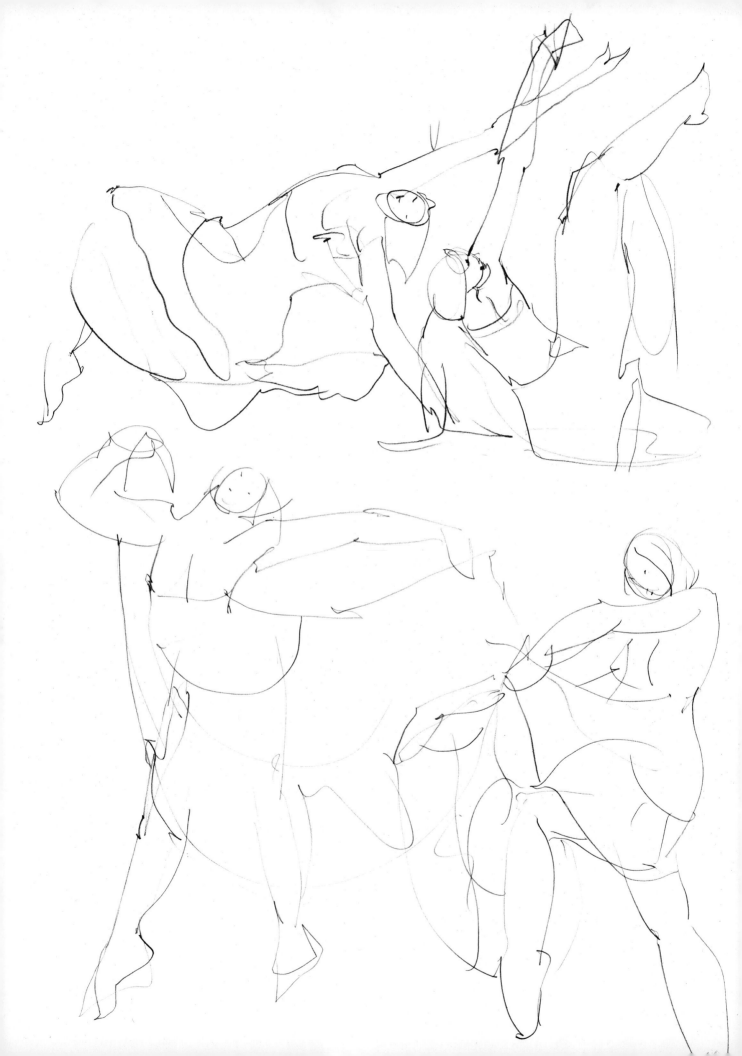

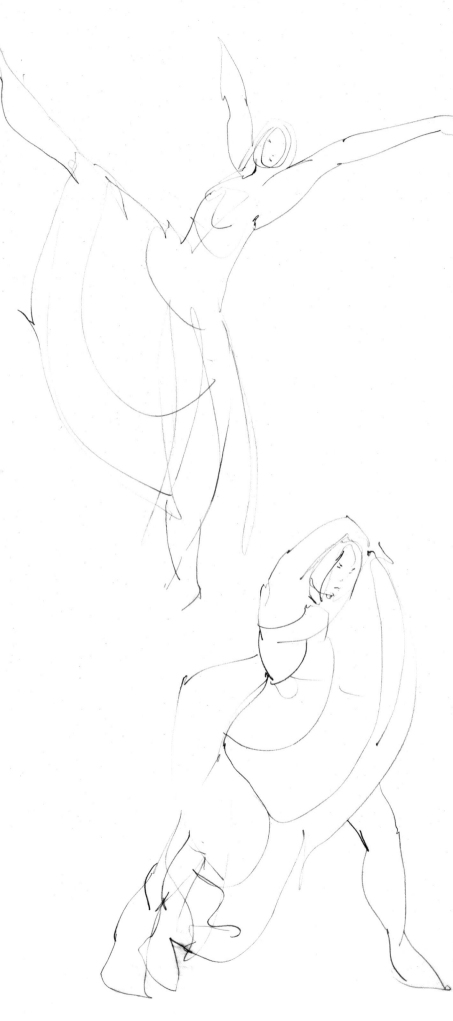

Figure Drawing Workshop

How to
Make Inspiring
Figure Drawings
in All Media

Carole
Katchen

WATSON-GUPTILL PUBLICATIONS
NEW YORK

This book is dedicated to the artists of Colorado who have continued to draw the figure even when representational art was considered passé.

Special thanks are given to Margaret Gaskie, Brad Henderson, Joanne Lawrence, Ken Malagisi, Ron Sanchez, Colleen Sullivan, and everyone at Pallas Photo.

First published 1985 in New York by Watson-Guptill Publications, a division of Billboard Publications, Inc., 1515 Broadway, New York, N.Y. 10036

Library of Congress Cataloging in Publication Data

Katchen, Carole, 1944-
 Figure drawing workshop.

 Includes index.
 1. Figure drawing—Technique. I. Title.
NC765.K38 1985 743'.4 84-26917
ISBN 0-8230-1697-8

Distributed in the United Kingdom by Phaidon Press Ltd., Littlegate House, St. Ebbe's St., Oxford

Manufactured in Japan

1 2 3 4 5 6 7 8 9 10 90 89 88 87 86 85

CONTENTS

INTRODUCTION

I love drawing people. I've been doing it my whole life, as a professional artist for over twenty years. Of course, when I first started I didn't call it figure drawing; I was just drawing pictures of people, and I did it because it was fun.

Through the years I have learned something of line, value, perspective, and anatomy. I have taken classes in figure drawing and I have taught classes in figure drawing. I have learned what a complex, challenging, and often frustrating activity it can be, but I still do it because it is fun.

This book is designed for artists who feel the same way I do and who want to share the joy and knowledge of other figure artists. It is called *Figure Drawing Workshop* because it was set up like a workshop.

Imagine a weekend workshop where nine professional artists have been brought together to pass on the techniques of figure drawing in which they are most proficient. In this book we have brought together nine artists who are knowledgeable, skilled, and articulate. Each one uses a section of the book to talk about and illustrate one important element of figure drawing.

This book begins with line, the foundation of figure drawing. I chose *Mel Carter* to present the element of line in drawing because line is the backbone of his figurative work. In the classes he teaches at Community College of Denver, Carter demands that his students practice drawing with all sorts of lines. However, this pursuit of line is not just something that he requires of his students. In Carter's own figure drawings he works with pencils, pens, brushes, crayons, even twigs and ink—any implement he can find that creates a line.

Moreover, Carter is never satisfied to use an implement or medium in the most conventional way. When he draws with pencil, he draws with the point and with the edge of the lead. Then he will run the pencil through a wet watercolor wash, creating a new line by using his pencil to pull the watercolor across the paper.

Carter teaches that the only limitation there is to the creation of lines is the imagination of the artist. "It's not enough just to draw," he says. "You must also see and think and feel. The excitement you feel about the model and about the act of drawing will appear as excitement in the line."

Bob Thomas had a traditional academic art education. Even though much of his work now is non-objective, he still understands and enjoys using the classical art skills that he learned as a student.

The component of drawing that Thomas teaches best is the use of value in the rendering of a human figure. How does light fall on a body? Where does the absence of light create shadows? How do the light areas and the dark areas blend together?

Thomas understands the relationship between actual light and the representation of that light in a drawing. He uses this knowledge of value effectively in his own work and is able to share this mastery of light and shadows with his students.

I chose *Bob Ragland* to talk about finding and posing models because Ragland is a man who surrounds himself with people. He regularly draws live models to improve his drawing skills, but he doesn't think of human models as objects to be drawn like apples and oranges; to Ragland each model is a person with individual personality, gestures and moods.

During each session he draws the model in a variety of poses and expressions, always concerned about the comfort and naturalness of the subject. For Ragland drawing is a means of exploring the individual. He enjoys drawing as a discipline and as a means of expression; but, most important, he sees it as a way of getting to know and understand other people.

The drawings and paintings of *Kim English* have a natural, everyday quality with which every viewer can identify. What makes them believable is English's ability to capture gesture. He shows people in commonplace actions, walking, chatting, eating;

and his masterful rendering of the twists and bends and tilts of their bodies tells us what is happening in the scene.

"I draw because I like getting wrapped up in a world of ideas," explains Kim English. "I like to show people that just about anything is pretty. It's not what you see, but how you look at it."

Doug Dawson was a natural choice for showing the expressive qualities of drawing, because his work is so highly emotional. Even when he is painting a commissioned portrait, his primary concern is for what the subject is feeling. His work projects the personality and mood of the subject. It captures the ambience of the situation; and it also evokes a strong emotional response from the viewer.

Dawson is not happy just to let the viewer look at his work, say "Oh, how pretty" and walk away. Dawson has a passionate involvement with what he draws and paints, and he demands a passionate response from the viewer looking at one of his paintings.

I chose *Claire Evans* to teach the techniques of drawing a likeness because that is what Evans likes to do—she loves the challenge of creating a picture that looks like the subject. In a time when people take photographic portraits for granted, Evans believes that a drawn or painted portrait captures more of the soul of the subject and the artist than a photograph does. She has devoted years of her life to the discipline of capturing a particular person in a drawing; and in her chapter on capturing a likeness she shares what she has learned.

Much of *Karmen Effenberger Thompson*'s work involves groups of figures, and she arranges those groups with a brilliant and inventive sense of design, which is why I chose her to present the challenge of drawing figures in groups.

In Effenberger Thompson's work she has drawn groups of every size and configuration: theatrical characters on stage, relaxed families on the beach, and swarming politicians at conventions. The common element in all of these drawings is the way she uses the shapes of people and other elements to create patterns. It is the pattern or design that she sees first of all; the individual characters are important only as they fit into the total picture.

I selected *Shawn Dulaney* to show how one draws figures in motion because the focus of Dulaney's life is movement. From early childhood she has been a dancer, learning to express thoughts and ideas through movement. It is natural that when she became a visual artist, she wanted to draw moving figures.

Dulaney says it helps her drawings that she is a dancer; but that any person who moves can learn to draw figures in motion by learning to be sensitive to his or her own movement. You must ask yourself: How does it feel when I walk? How does it feel when I turn? What do my arms feel?

Dulaney says you must become aware of how your own body feels. Then when you are drawing a moving figure, you not only see the movement, but you also feel it in your own body, and those feelings are what make your drawing work.

The basis of my own drawings is composition. Much of my work is intuitive. Line quality, gesture, expression, color—those elements in my drawings are based on how they feel rather than on intellectual analysis. But, the one component that I always do plan consciously is composition. I have learned that if the basic design of a drawing is unsound, then there is no way to make that drawing work.

I begin my drawings with the basic division of space and then add the concerns of balance, rhythm, tension, and movement. Nearly all the art I do is of people, singly or in groups, sitting for a formal portrait or mingling in a social situation. I approach each piece as an individual challenge, choosing a size and medium appropriate for that particular subject. The one aspect of my work that remains constant is my concern for composition.

As you read on and meet each of the nine workshop artists, you will be introduced to the various disciplines that are vital to the art and craft of figure drawing. Each section is intended to develop your skills in observing and drawing the human figure. But before you begin, take the time to get yourself the tools of the figure artist—a sketchbook and some kind of drawing medium, such as a simple graphite pencil or a small set of pastels. Then, as you observe each artist's expression of the figure, you can apply the techniques you've learned to your own drawings. Most sections include a specific assignment that reflects the particular aspect of drawing discussed.

Remember, great drawing comes from knowing and using a medium until it becomes an extension of the artist's hand. The medium and the technique must reach a point where you are not aware of them. Drawing technique is a matter of training the hand, but the artist must also train the eye. In the long run, learning to draw is learning to see. So, take your sketchbook and pencil in hand and see how each of these artists interprets the figure in his or her own way, and then go on to create your own expression of that most inspiring of subjects—the human figure.

—*Carole Katchen*

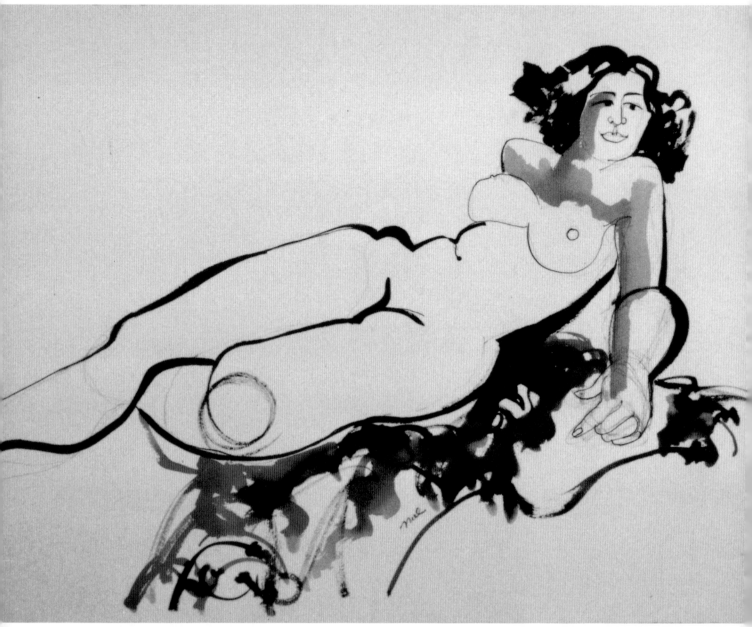

TISSA, mixed media, 20″ × 26″ (50.8 × 66 cm).
This drawing shows how a calligraphic brush-and-ink line can be used effectively with the finer pen-and-ink contour. Carter uses the heavy brush line for only part of the figure's outline; this allows the viewer's eye to move more easily between the figure and background. The activity in the bedspread is a combination of wet and dry brushstrokes. Notice how the curved lines in the spread relate to the curves of hair and figure.

1 LOOKING FOR A NEW LINE

Mel Carter

The first and simplest use of line is to define shapes. When an artist draws a line across a page, the line divides the page into two shapes. In drawing a figure, a line around the figure separates it from the space around it, creating figure and ground or positive and negative space. For artist Mel Carter, however, dividing space is only the beginning use of line. In Carter's work, the line is the drawing.

Mel Carter's figure drawings illustrate that every line has its own personality, its own character. He draws with lines that are light and elegant and lines that are blunt and powerful. He explores the figure with tentative lines, then restates it with adamant lines.

Carter says that line gives strength to drawing; it adds vigor and sensitivity. Line can create activity or movement, or show value and project mood. Line shows the contour of the figure and the gesture, describing the shape of the skeleton and the movement of the muscles.

THE PERSONALITY OF A LINE

When Mel Carter teaches a drawing class, he stresses that every line is different; each line has a personality. The lines vary according to the direction, weight, speed, and medium with which they are drawn.

Carter points out the difference between straight lines and curved lines. He explains that even though most students think this difference is obvious, few realize the different feelings evoked by these simple lines: a straight line seems hard, direct, absolute, strong, fast, whereas a curved line feels organic, delicate, sensual, relaxed.

Carter maintains that the emotional statement made by a line is important to figure drawing because it contributes greatly to the feeling of the total drawing. Thus, a figure drawn with straight lines will tend to look stiff and mechanical; a figure drawn with all curves will look soft and sensual. He suggests that students try drawing a figure with all straight lines, then with all curves to see how the personality of lines affects the drawing.

Most figure drawings are a combination of curved and straight lines. Carter says the best drawings occur when the artist has a great sensitivity to the kinds of lines that are used. When he draws, he looks first at the model to see what feelings the drawing should project, then he concentrates on producing lines that convey those feelings.

Direction change is also important. A curved line is actually a line that slowly changes direction. The curve feels vastly different from a line that abruptly changes direction, thereby making a sharp angle.

There are other directional influences on line as well. A drawing with a dominance of horizontal lines will appear more stable than one with vertical or diagonal lines.

The weight of a line is an important factor in line drawing; it indicates the importance of a line and also implies distance. Carter tells his students to let a line flow around the figure, tracing the figure. In some places, he says, draw a thick, heavy line; in other places let it go so thin that it

almost disappears. Then he points out that the heavier lines command your attention first; they become more important because they are easier to see. And the thick lines appear closer to the eye and the thin lines recede, a technique which can be used to show where parts of the figure exist in space.

The speed with which a line is drawn also has an effect on the personality of a line. A line drawn quickly is usually more fluid and direct than one that is drawn slowly and meticulously. If the artist varies the speed of drawing within a line, moving faster through some parts of it and slower through others, it will create variations within the line that add interest to the drawing.

PENCILS, CRAYONS, BRUSHES, AND TWIGS

Different implements create different lines, even using the same tool in different ways changes the line quality.

There are two types of drawing media: dry and wet. Dry media include pencil, charcoal, pastel, and crayon. Even such a basic tool as a pencil can create a variety of lines. If you use a sharp point the pencil creates a fine, sensitive line, and a dull point creates a thick line in which the duller the point, the thicker the line. If you turn the pencil on its side, you can achieve a blunt line. All the dry media can be sharpened with a pencil sharpener, razor blade, or piece of sandpaper.

In addition to variations in thickness, lines created from dry media can be light or dark depending on how soft your implement is and how much pressure you apply. A soft lead pencil makes a darker line than a harder lead, and the same pencil creates a darker line if you apply more pressure.

One tool that is rarely thought of as a drawing device is the eraser. If you cover your paper surface with a layer of graphite or charcoal, you can then "pull out" lines with your eraser.

Ink and paint can also be used for drawing. However, once you've made your line with wet media, it is much more difficult to change than dry media. Mel Carter says, "One reason I draw in wet media is it provides such a challenge. Once you put a line down, you can't change it."

The main tools for wet media are brushes and pens. Brushes are either flat or pointed, large or small. Pointed brushes give the most variety, but flat brushes can also create an interesting line.

There is a tremendous variety of pens available to the artist. Speedball pens come with a wide assortment of points that give a consistent line. Quill pens require more control to prevent blobs and blotches, but they allow infinite variation within

the same line. Bamboo pens and sharpened twigs result in wide, often more primitive lines, but again offer great variety. The most controlled lines are achieved with a technical or Rapidograph pen, which gives a very fine, consistent line.

The type of implement you choose should be determined by the quality of line you want to achieve. Mel Carter maintains that the only way to develop assurance about media is to experiment and to try out every kind of drawing implement you can find. In his own figure drawings, Carter often mixes his media and uses several different implements to create an interesting variety of lines within the same drawing. "No one kind of line is better than another," Carter says. "They are just different. With ink, for instance, you get definition and prominence: you get a strong line even when it is very thin. Ink reads with firmness, like speaking in a loud voice. Sometimes you want to whisper instead, and then you use a pencil."

In addition to experimenting with drawing implements, Carter instructs students to try many kinds of surfaces. Any kind of paper can be used for drawing. However, he cautions that papers with a high woodpulp content, such as newsprint, can discolor and disintegrate quickly. If you are concerned about creating drawings that will last, you should use papers made of cotton rag or other nonacidic fibers or papers that are chemically treated for permanence.

Most drawing papers have some degree of "tooth" or roughness. Although random patterns are available, many charcoal and pastel papers are made with a tiny geometric pattern in their surface. Carter suggests trying papers with a less consistent texture, such as rice paper, and also papers with a very smooth finish, such as bristol board.

SOME CATEGORIES OF LINE

The lines that are used to render figures are often divided into various types. Here Carter defines some of the most common categories:

- *GESTURE LINE*—A quick, loose line that defines the activity of the figure. It is one way of memorizing the figure with your pencil. Many artists use gesture drawings as a way to warm up for more precise drawing, the way a pitcher throws some practice pitches before he begins to play.
- *CONTOUR LINE*—A continuously drawn line that describes the shape of a figure or object with more exactness. However, a contour drawing is more than an outline. The outline alone creates a silhouette; the contour line suggests more of the solid form and movement of the figure.

- *BLIND CONTOUR LINE*—This is done by starting your line at one point on the figure. Then you move your eye in a continuous line to describe the entire form. Simultaneously, you move your pencil at the same speed and in the same direction as your eye. You should *not look* at the paper until the drawing is finished, relying absolutely on eye-hand coordination. Carter says this technique frequently produces an interesting line but rarely captures the beauty of the figure.
- *BROKEN CONTOUR LINE*—A contour line that is not solid. Carter cautions that you should only break the line where you have a reason for doing so, for example, to indicate a less important area.
- *CALLIGRAPHIC LINE*—A line that has the quality of oriental calligraphy, which means "beautiful writing;" a graceful, rhythmic, varied line.
- *HATCHED LINES*—Numerous repeated lines generally used to create value or dark areas.
- *CROSSHATCHED LINES*—Numerous repeated, intersecting lines, either straight or curved, used to convey value.
- *LOOSE HATCHED LINES*—Basically scribbled lines, used to show value.

1

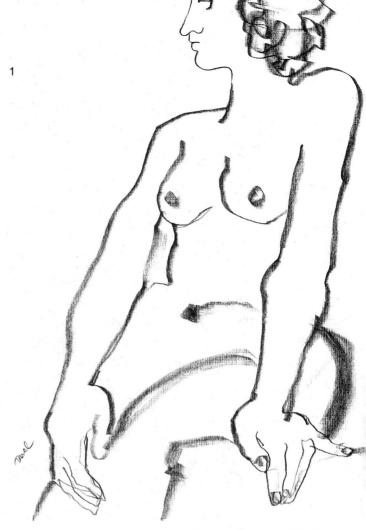

2

SIX LINE DRAWINGS

Every line has its own personality. Depending on the medium and technique with which it is drawn, a line is bold or tenative, aggressive, sensitive, rigid or fluid. In the following drawings Mel Carter uses the same figure in the same pose; the only variation is in the character of the line. Notice how one variation dramatically changes each drawing.

1. GRAPHITE

Graphite is available as lead in pencils and in solid sticks. Here Carter uses a stick of graphite. Notice how he achieves a thick line by drawing with the side of the stick; the fine lines in the face and hands are produced by drawing with the point of the stick. Notice the fluid quality of the line in the face. Carter could have chosen to create a delicate, graceful drawing by rendering the entire figure with that type of line. Instead, he used bolder, more angular lines to give greater vitality to the drawing.

2. CRAYON

Crayon has many of the same properties as graphite, such as the ability to go from thick to thin and from dark to light. Crayon is not quite as delicate as graphite (compare the faces in this and the graphite drawing), but it does create a much more dramatic black. Other media that are similar to graphite and wax crayon are Conté crayon and charcoal. The biggest difference is that Conté and charcoal are unstable substances that smear easily. Try using all four so that you can get a sense of each medium's advantages and limitations.

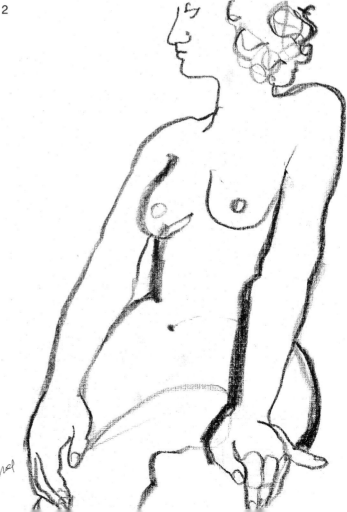

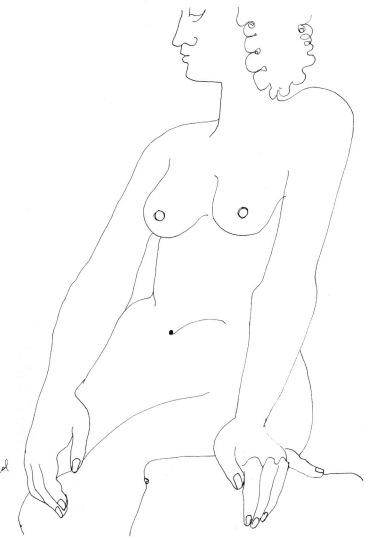

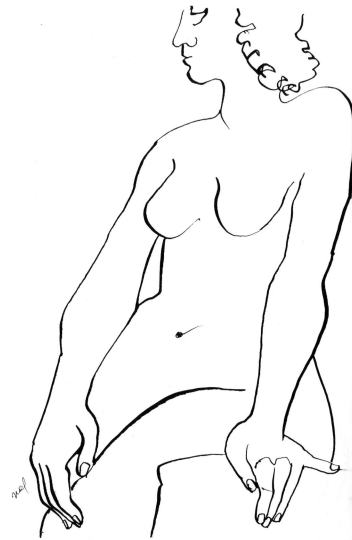

3. TECHNICAL PEN

With the technical or Rapidograph pen, Carter creates a line that is precise and controlled. The drawing has a delicate quality because the line is so fine; but because the medium used is ink, it is also a very firm line. Notice the playful quality of the curved lines in the hair. These whimsical circles and curves keep the drawing from looking too somber.

4. PEN AND INK

With traditional pen and ink, Carter achieves much greater line variation than is possible with the technical pen. Notice how the line varies from the very thin line delineating the nose to the thick lines in the torso and limbs. The lines here are also less fluid than those drawn with the technical pen, thus making the figure appear less graceful; however, because of their greater variety, the lines themselves have greater visual interest.

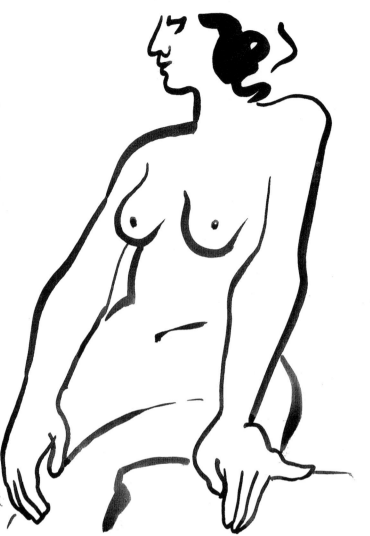

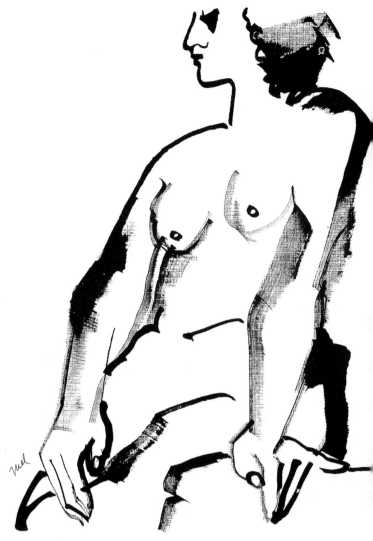

5. BRUSH AND INK
This brush-and-ink drawing has a lovely flowing line that is reminiscent of oriental calligraphy. To achieve this graceful line, Carter used a pointed brush with which he drew in long, continuous strokes. This is only one of the many types of lines that can be produced with a brush. Carter says that the only way to know what you can accomplish with any tool is to do lots of drawings with that particular implement. Your only limitation is your own imagination.

6. STICK AND INK
For this drawing Carter used a twig that he found on the ground. By dipping the stick in ink and drawing with it, he has achieved the greatest line variation possible in an ink drawing. Compare the fine lines in the face to the broad, textured lines in the arms and the heavy, black lines along the back of the figure. He controls the line by using more or less ink and by drawing with the tip or side of the stick. Another drawing tool that gives a richly varied line, but with more control than a twig, is the oriental bamboo pen.

LOOKING FOR A
NEW LINE

DRAWINGS USING REPEATED LINES

One line alone has an individual character; repeated lines create other effects. Repeated lines give emphasis to a section of a drawing. They can convey a feeling of movement or rhythm, and they can create areas of lighter or darker value. Drawing is a matter of creating illusions; overlaying or crosshatching lines can enhance those illusions.

1. CROSSHATCHING

This drawing was executed with fine, light pen lines. By themselves the lines are delicate, but together in the form of crosshatching they create a strong impact of light and dark area within the figure. Carter has placed his lights and darks in the drawing according to pure design considerations. However, it is also possible to use the values—the dark and light areas—to create a sense of solidity. As you read about value in the next chapter, imagine using crosshatched lines to indicate where light and shadow fall on the figure.

2. DIRECTED LINES

This drawing is an example of directed lines—that is, lines that are all traveling in the same direction. In this case they are all curved lines moving over the surfaces of the body. These repeated lines give an interesting rhythm to the drawing, and they add a sense of volume to the figure.

3. REPEATED LINES

This drawing is a wonderful example of repeated lines and the various effects they can create. Notice the lines that make up the figure's right shoulder. There are so many lines in this area that are repeated so closely that they give the sense of being one heavy line. Thus, the weight of these lines draws attention to that part of the drawing.

In the area of the other shoulder, one line closely parallels another. This repetition defines the contour of the shoulder, but with more vitality than one solid line. Throughout the breasts and torso area there are many arbitrary lines that intersect one another, which creates interesting shapes within the lines.

Notice the center line that starts at the neck, makes a jump at the collarbone, flows down to the breast, and then cuts back sharply into a curve across the contours of the breasts. This line illustrates how Carter's eye jumps around the figure in a fluid, rhythmic way. That particular line has a spontaneity that adds vitality to the whole drawing.

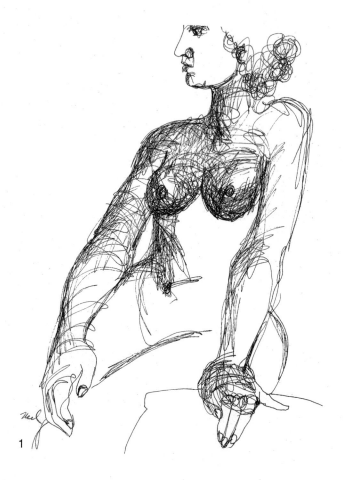

1

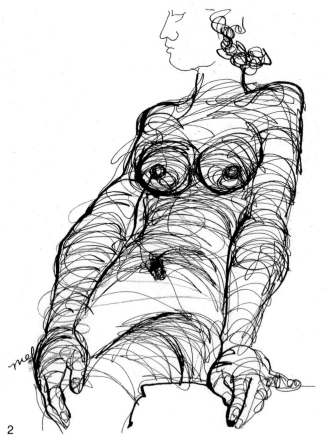

2

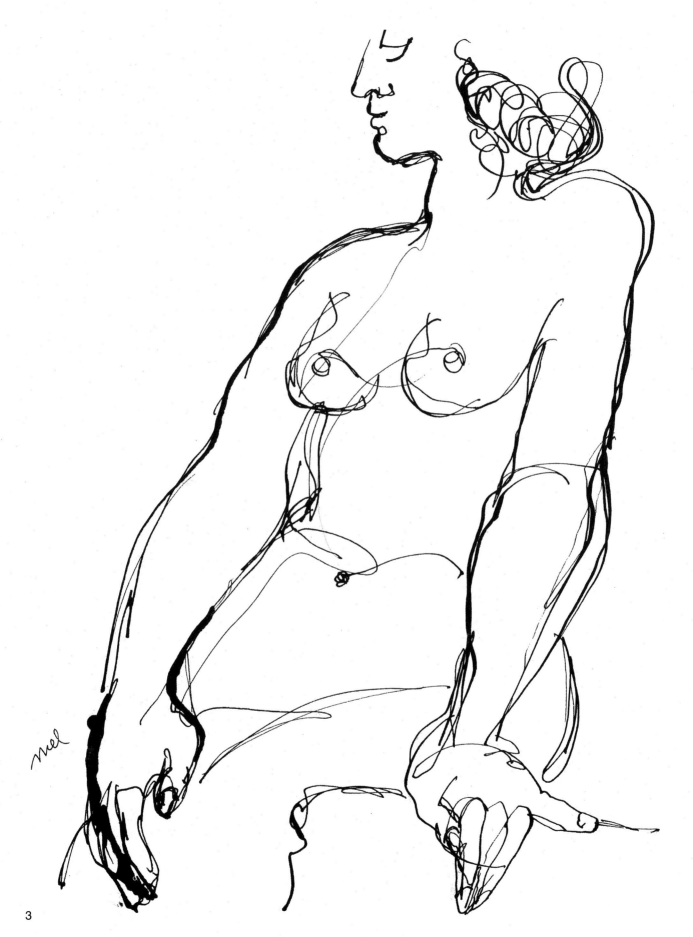

3

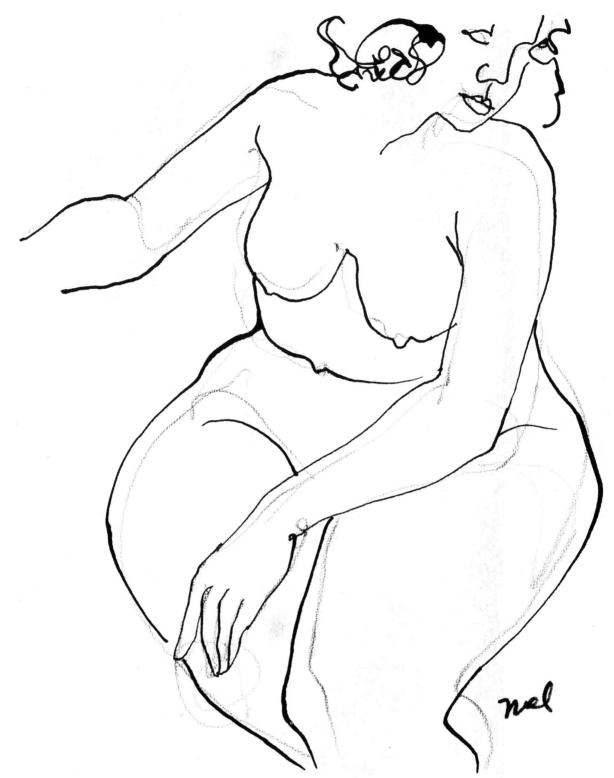

SEATED FIGURE., pencil and ink on paper, 8½" × 7" (21.6 × 17.8 cm).
The first step for Carter when drawing a figure is often a loose gesture drawing in pencil. The purpose of the gesture drawing is to place the figure on the page, to show the shapes of the body, and to establish the pose. After the gesture drawing, he draws a more precise contour drawing, often with pen and ink. Since he has already established the shapes and pose, Carter can now concentrate more fully on producing a strong, refined contour drawing. Many artists erase the original pencil sketch, but Carter leaves it. He feels that the combination of the loose pencil lines and the precise ink lines creates a more vital drawing.

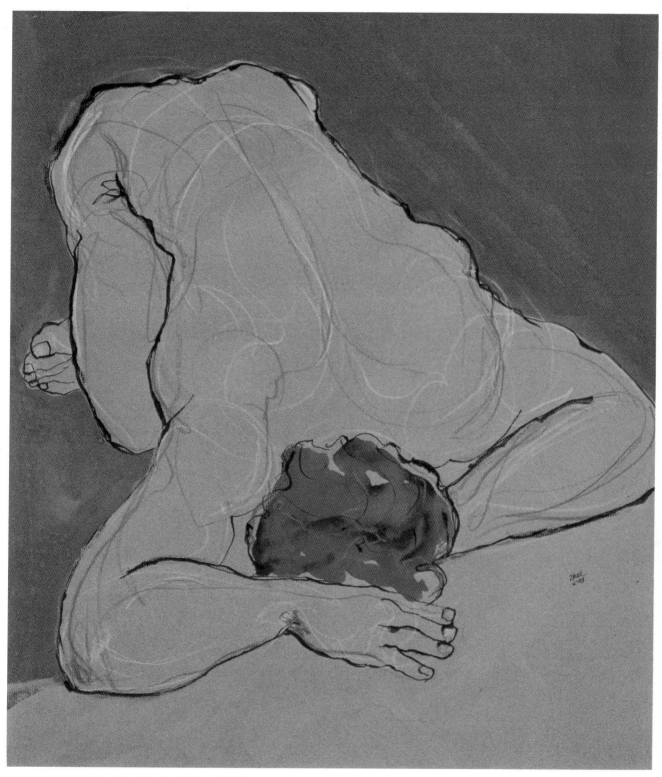

KNEELING BOY, mixed media, 20″ × 17½″
(50.8 × 44.4 cm).
This drawing shows how many media and many types of line can be successfully combined in one piece. The heavy contour line was drawn with a twig and ink. The playful lines on the surface of the figure were drawn with pastel. The thick blue lines in the foreground were also made with pastel, but with the side of the pastel stick. The draperylike lines in the background are brush and watercolor.

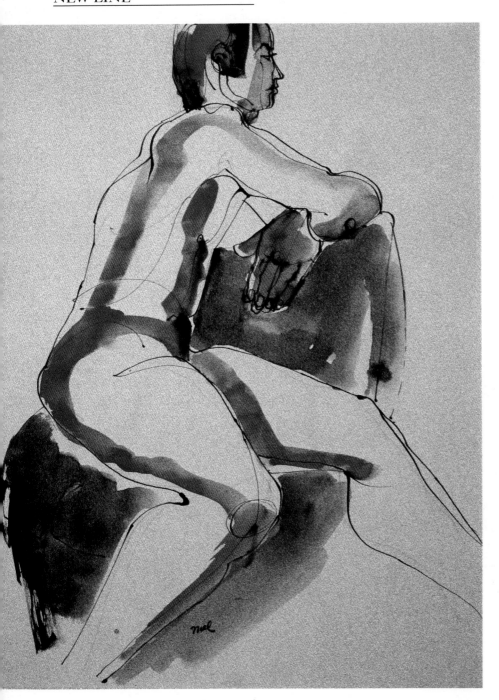

RICHARD SEATED ON A BLUE CHAIR, mixed media, 23½″ × 18″ (60 × 45.7 cm).
This drawing is a good example of repeated line used to create a sense of movement. Notice the three lines that make up the profile of the model's face. Once again, there exists strong contrast between the thick, straight brush lines and the thin, curved pen lines.

ELIZABETH, pencil and watercolor on paper, 22″ × 17″ (55.9 × 43.2 cm).
The lines in this piece give a sense of the character of the model. Around the shoulders and hips, the lines are strong, direct, almost masculine; these lines are countered by the lovely, graceful curves in the face. Notice also how Carter has created the white lines around the figure simply by not using color there.

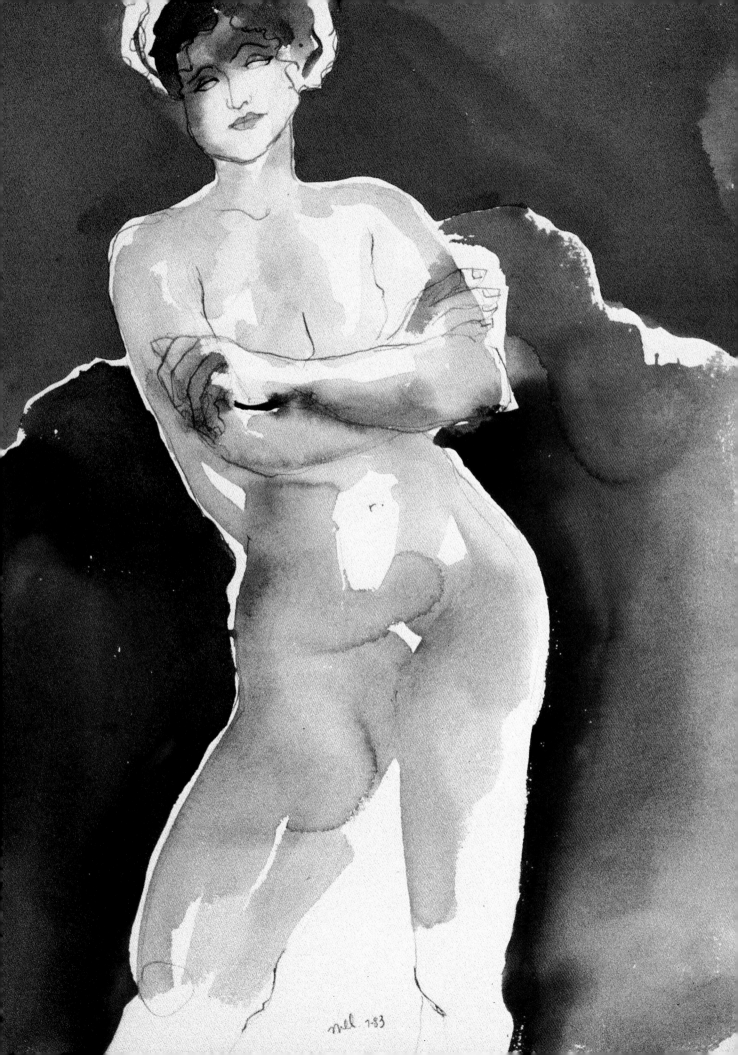

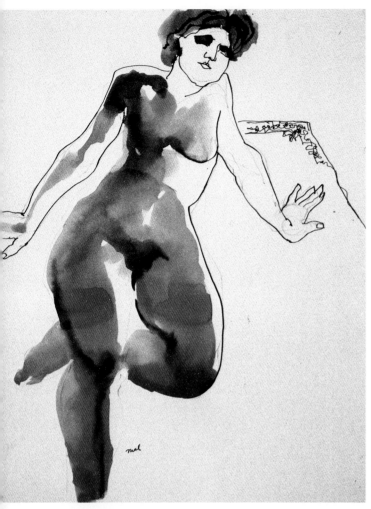

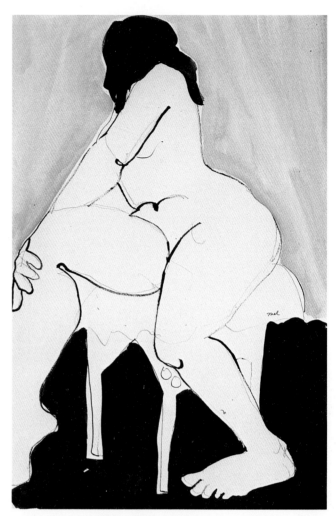

YOUNG DANCER, mixed media, 23″ × 18″
(58.4 × 45.7 cm).

Carter has created a great variety of line in this piece. A heavy black line describes the figure's left side, but the right side is indicated with just the edge of the watercolor wash. Notice the thick lines created with a brush and ink in the model's right arm and with blue paint in the model's right leg. These thick brush lines add interesting contrast to the fine pen lines.

GIRL ON A STOOL, ink and watercolor on paper,
19″ × 12½″ (48.2 × 31.6 cm).

In this simplified rendering of a female figure, we see the vital line that can be created by drawing with a twig dipped into ink. Notice how within the same stroke the line varies from thick to thin, dark to light, solid to textured.

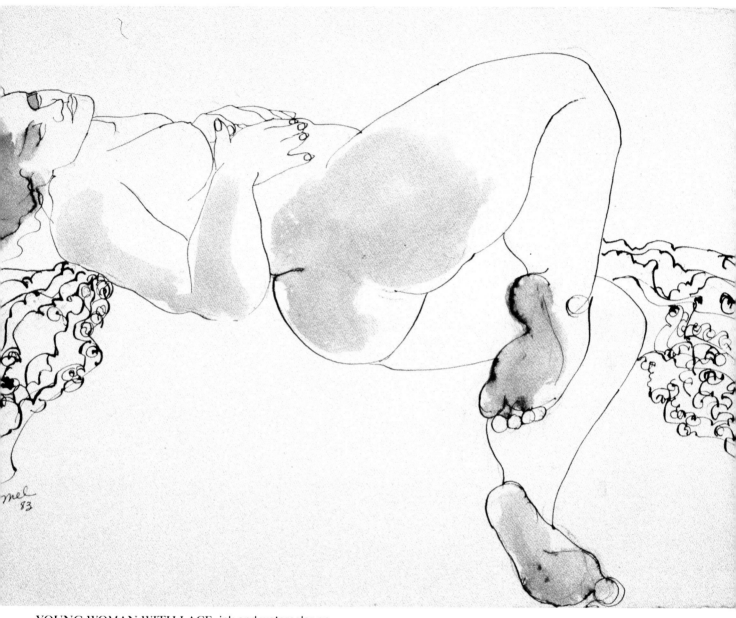

YOUNG WOMAN WITH LACE, ink and watercolor on
paper, 17″ × 23″ (43.2 × 58.4 cm).
*This is a wonderful example of calligraphic line. Notice how
the lines of the figure flow in elegant curving strokes with
great variety of line thickness. Rather than drawing each
detail of the lace, Carter has abstracted the lace; that is, he
has drawn the general shapes to give a feeling of lace.
Notice how the busy, repeated, small curves of the lace
make the large, flowing curves of the figure appear even
more graceful.*

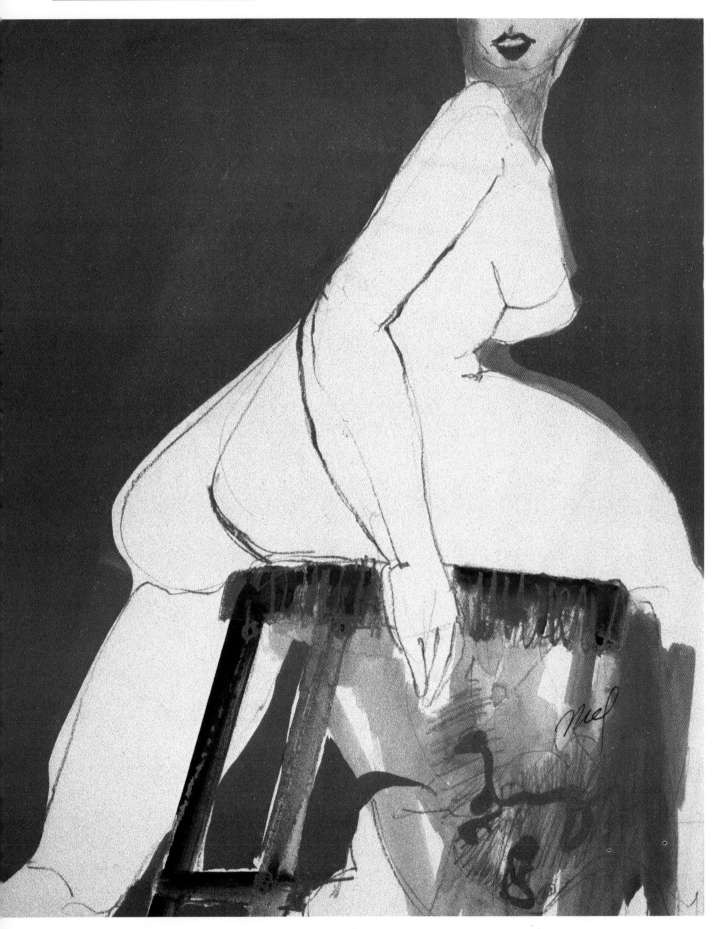

(left) MY FRIEND MARY JANE, mixed media, 22″ × 18″ (55.9 × 45.7 cm).
Here Carter has simplified the lines and shapes of the figure for the sake of the total design. He has achieved great variety of line by varying the pressure of the red crayon and by turning it from its tip to its side. Note the use of repeated lines to create interesting textural effects in the drape over the stool.

(top right) SYLVIA, ink and watercolor on paper, 20½″ × 15″ (52.1 × 38.1 cm).
Here Carter has taken a horizontal, reclining pose and made it more dynamic by placing himself at the model's feet and drawing from that unusual perspective. In this piece the contour is a fine line drawn with pen and ink. This is a more lyrical line than that obtained with a bamboo pen or twig and ink. Notice the rhythm created by the repeated lines of the toes.

(bottom right) PORTRAIT OF LOIS, ink and watercolor on paper, 22″ × 14″ (55.9 × 35.6 cm).
One of the most basic uses of line is to define or separate shapes. This is how Carter used line in this piece. He drew a basic contour drawing of the figure, then filled in the shape of the figure with a dark watercolor wash. The final effect is a basic silhouette of the figure.

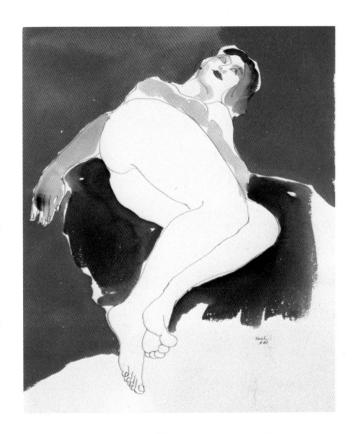

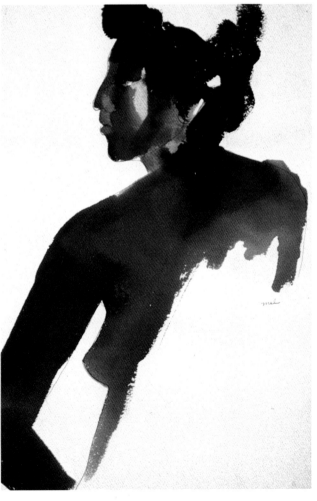

23

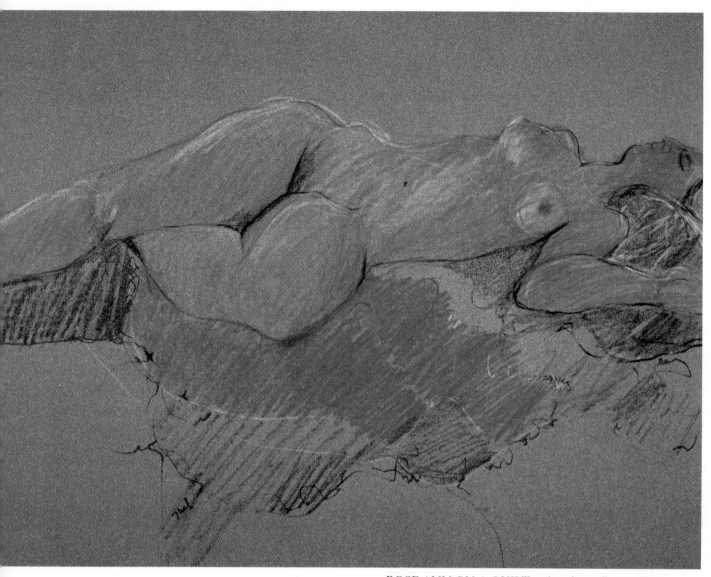

ROSE ANN ON A QUILT, colored pencil on paper,
18″ × 23½″ (45.7 × 60 cm).
*Here Carter uses hatched line to convey value and color.
Notice how the repeated lines of blue, for instance, flow
together to create the sense of a solid blue shape. He uses
lines of darker value to give the sense of shadows, and lines
of lighter value to create highlights.*

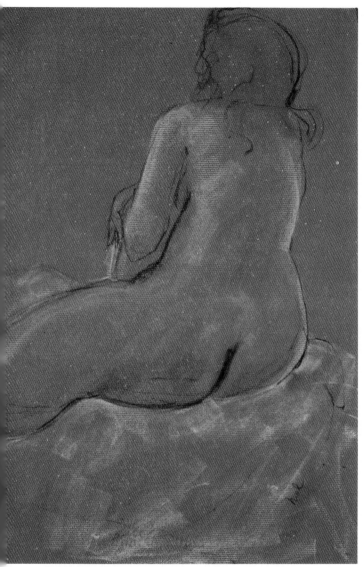

REDHEAD, pastel on colored paper, 23″ × 16″
(58.4 × 40.6 cm″).
Here Carter has combined two kinds of pastel lines: the thin, specific lines drawn with the tip of the pastel stick and the thick, more general lines achieved by using the pastel on its side. Here, the thin lines describe the contours and the details of the hair, and the thicker lines show the surface tone of the large masses.

1. Choose any drawing implement—pencil, pen and ink, a stick of charcoal, brush and paint. On a large sheet of blank paper, draw as many different kinds of lines as you can with that implement. If you are working with a pencil, for instance, draw lines with the point of the pencil, then with the side of the lead. Draw a dark line with heavy pressure, a light line with little pressure, and a line where you vary the pressure from light to medium to heavy. Draw straight lines, curved lines, and jagged lines. Create a line with a series of dots. When you have exhausted your imagination, put that sheet of paper aside.

Now on a clean sheet of paper, draw a figure, using the same drawing implement. In your figure drawing use at least ten different kinds of lines. Refer to your line study to find new lines to use with the figure.

2. The subtle curves of the lines of the body are difficult for the beginning artist to learn to see. Most beginners draw arms, for example, with straight or nearly straight lines. However, the contour of an arm, even when fully extended, is comprised of many small, interesting curves. This curved contour line shows the shapes and angles of the bones and muscles beneath the skin. One way of learning to see the subtleties of contour is by doing blind contour drawings.

Place yourself in front of a seated or standing model with a large sheet of paper and a stick of graphite, charcoal, or Conté crayon. With your eye, locate the center point of the top of the model's head, and place your drawing implement at the center point of the top of your paper. Now move your eye slowly along the contours of the body: from the center of the head to around the ear, along the jawline to the neck, the neck to the shoulder, and so forth. Your eye should move in one continuous line around and through the entire body.

As you move your eye, move your hand holding the drawing implement at the same speed and in the same direction as your eye. Your hand should be creating one continuous line that encompasses the entire body. Move your eye and hand very slowly, looking for all the subtle curves of the figure. *Do not look at your paper until you have completed the entire drawing!*

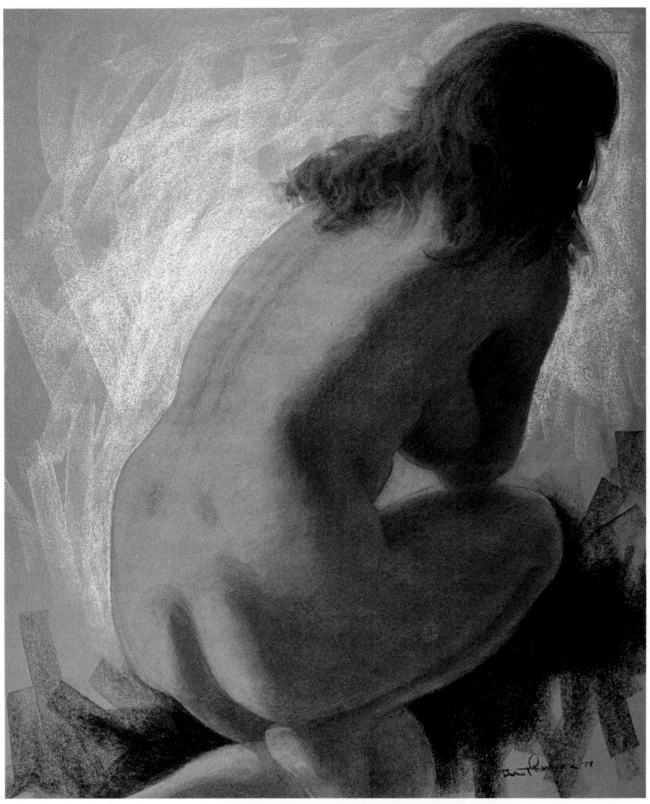

LIGHTED NUDE, mixed media, 35″ x 29″ (91.4 x 73.7 cm).
A mood of mystery is suggested here by placing the head and front of the figure in shadow. Notice how Thomas has maintained the division of light and dark sides in the figure. On the light side the details of the spine and pelvic indentations are definite, but soft enough not to interfere with the continuity of the light. On the other side the dark flows directly down the figure, with variety but no interruptions.

2 WHERE DO YOU PUT THE SHADOWS?

Bob Thomas

Classical figure drawings are a combination of line and shadow. We have already discussed line, but what is this other element, shadow?

In simplest terms shadow is the absence of light. We are able to see objects because of the light being reflected off them. Where the most light is reflected, the object is brightest; where there is the least light, the object is darkest. The brightest areas in a figure drawing occur where the most light is shining on the model. The shadow areas show where there is the least light.

By adding shadows to a drawing, however, an artist achieves much more than just showing where the light is shining. Shadows help create the illusion of three-dimensional form. They indicate the anatomy of the figure, and they help express the mood of the model and the finished drawing.

BOB THOMAS ON SHADING

A master of shading the figure is Bob Thomas. For Thomas, drawing the figure is a searching process. He works and reworks and *reworks* the lines and shadows of every drawing until a solid figure emerges; and it is this exploration process that is the essence of his work.

Thomas works slowly and thoughtfully. He begins a drawing with brief, light strokes that indicate the basic shapes and directions of the body. Then he wipes out everything but a light ghost image of the original drawing, and then starts over on top of that. He repeats this process many times in every drawing, building, correcting, and refining with each effort.

Bob Thomas explains the process this way: "Sometimes students make a commitment too quickly—to a line or to a shape—rather than looking on a drawing as a process of searching for the figure. I can put down twelve lines for the back and of those only *one* feels right. But if I had not

put down those other eleven, I might never have found the right one."

Thomas starts a drawing with vine charcoal, drawing general indications of the total figure. He begins by drawing the large shapes, leaving the details until later. He uses vine charcoal because it is an unstable substance, easy to blend or erase. He softens the early marks with a fingertip or rag or kneaded eraser, adding layer upon layer of charcoal until he is confident that he has found the basic form of the total figure.

When he feels he has arrived at the major shapes and proportions of the body, he begins to work with compressed charcoal, which is harder than vine charcoal and makes darker, more permanent marks on the paper. Then he draws in smaller shapes and darkens the shadow areas, still working loosely enough to make changes. He continuously backs away from his drawing, comparing it to the model before him. Finally, when he is satisfied with the basic drawing, he picks out highlights with his eraser and draws in dark accents and the darkest shadows with a black Alphacolor stick.

THOMAS'S 1–2 APPROACH

How does an artist know where to draw the shadows? Thomas says that a beginning artist should start by establishing a single light source. Thomas does this by placing the model in dim light and then shining a spotlight on the figure. He uses a strong light with a reflector so that he can direct the light. Then, he says, squint your eyes (or take off your glasses). Squinting takes the figure out of focus, enabling you to see just the shapes of the dark area and the light area.

Thomas begins every drawing by dividing the figure into a light area and a dark area. This is what he calls his 1–2 Approach. He says this basic division into two values is enough to suggest the

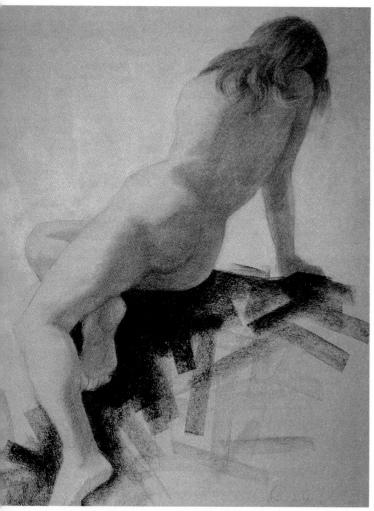

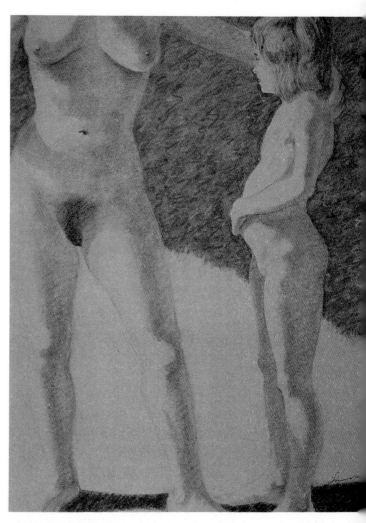

TINA, charcoal and pastel on paper, 27″ × 35″
(68.6 × 91.4 cm).
*There are basically only two values in this figure, a value
scheme that illustrates Thomas's 1–2 approach to value.
Because the left side is bright and the right side is dark, the
light source appears to be shining from the left onto a solid
figure. When the shadows are drawn so simply, they must be
well-placed in order for us to believe that the figure is three-
dimensional.*

MOTHER AND CHILD, mixed media, 35″ × 29″
(91.4 × 73.7 cm).
*Thomas dramatizes the shapes of the two figures in this
drawing by using a strong side light that gives very definite
highlights and shadows. Notice the cast shadow of the
mother's arm across her abdomen; even though we see only
part of the figure, that cast shadow helps us accept the
existence of what we don't see.*

(right) BALI GIRL, pastel on paper,
35″ x 29″ (91.4 x 73.7 cm).
*The realistic feeling of this drawing is created by Thomas's
sensitivity to light. The woman is obviously in bright sunlight,
an impression created by the strong contrast between the
highlights and the dark shadows.*
 *When working with values in color, it is important to be
aware of warm and cool colors. The light can be either warm
or cool; the shadows are usually the opposite. If the light is
warm, the shadows are typically cool; if the light is cool, the
shadows are warm. In this drawing the color of the light is
warm and the color of the shadows is cool.*

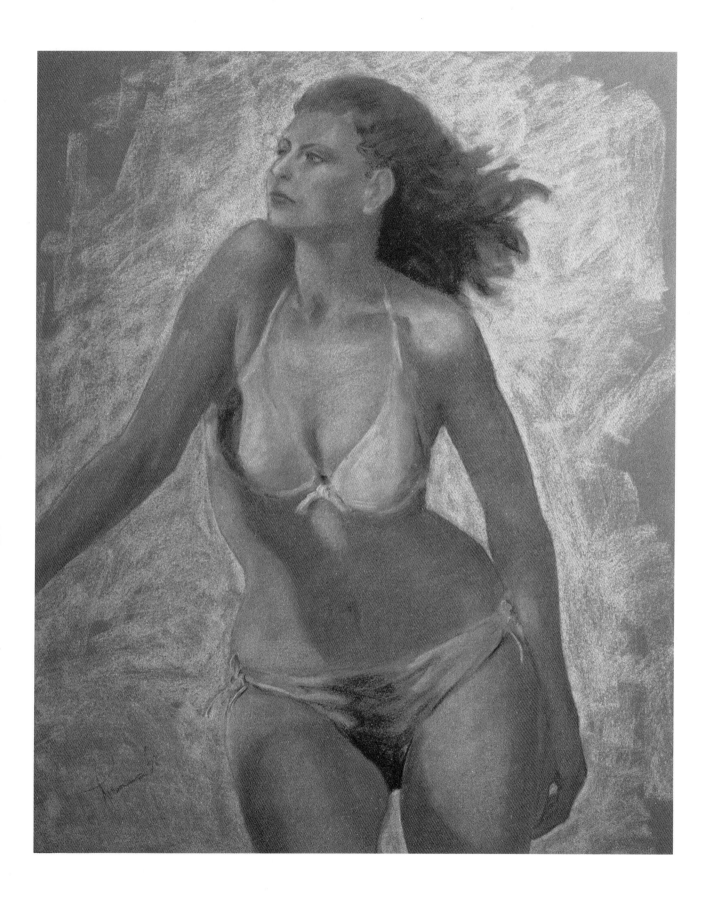

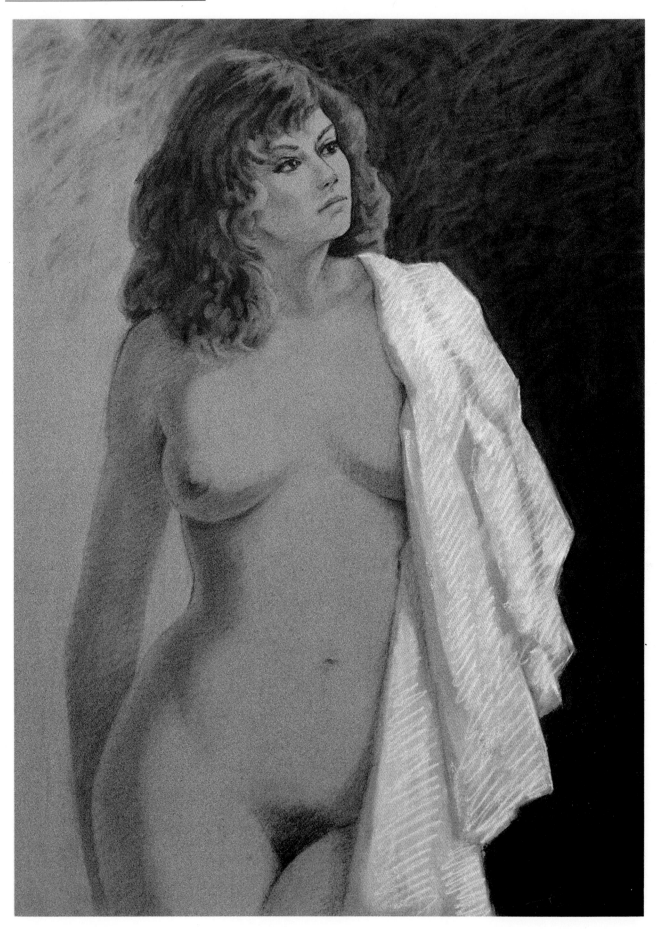

light and solidity of the figure. Especially for the beginning artist, it is important to keep the shading simple and to give only as much information as is necessary. If you provide too much detail, you start fracturing the solidity of the figure.

In the initial stages of the drawing, Thomas draws a light side and a dark side, working first with the large, general shapes. Then he develops only enough detail within the figure to suggest the anatomy. He explains, "There is a tendency to give the viewer too much information. I'll point at a dark stroke on the light side of a student's drawing and ask, what is that? The student says, 'that's a rib.' And I answer that it's not a rib, but a dark spot that is interrupting the fluid movement of the light side of the figure. A mere suggestion can give you all the information you need to have—a soft gray shadow, rather than a heavy black stroke. Maybe you don't need to indicate that rib at all. Learn to edit: Is this detail serving a purpose? No? Then get rid of it."

In Thomas' 1–2 Approach the highlights on the bright side should be lighter than the highlights on the dark side; the shadows on the dark side should be darker than the shadows on the light side. If, for instance, a highlight on the dark side is as bright as the highlights on the light side, that highlight will pop out and make the figure look flat.

DA VINCI'S THEORY OF VALUES

After you have mastered the basic division of values into one light and one dark, it is then possible to develop greater varieties of shading. Thomas says there are numerous theories for the division of values, but his favorite is Leonardo da Vinci's. Leonardo divided shading into five degrees of value:
1. direct light
2. indirect light
3. shadowed edge
4. reflected light
5. cast shadow

These five value distinctions can be illustrated by setting a white ball on a white table with a white background. The same five gradations should be visible when looking at a model or a well-rendered drawing of a figure.

An object is brightest where the light hits it directly. As the angle of the light source to the object becomes less direct, the object appears darker until it reaches the dark shadowed edge. Reflected light and cast shadows vary in value according to the intensity of the light and the surface upon which they are cast.

An understanding of these gradations of value can help the artist place the relative light and dark areas in a drawing. When in doubt about whether one shadow area should be lighter or darker than another, Thomas advises looking carefully at your subject. At first it is difficult to discern the subtle value differences in perceived objects, but with continued study the eye becomes more and more sensitive to subtle changes of light and shadow.

FIGURE–GROUND RELATIONSHIPS

When shading a figure drawing, it is important to be aware of the lights and darks in the background as well as in the figure. Thomas says that the figure and the space around the figure—the negative space—must be considered equally. One reason for drawing shadows in a figure is to create the illusion that the figure is three-dimensional. In order to complete the illusion, however, it is necessary to create a three-dimensional space in which the figure exists. This can be done by extending the shadows into the background.

Another use of the background is to help describe the shapes of the figure. If, for instance, a light arm is placed against a black background, the shape of the arm is obvious by value contrast and does not need the help of any contour lines. A third use of the background is in establishing a psychological setting for the figure. If the background is light or dark, simple or busy, it will affect the emotional tone or mood of the drawing.

DRAPED NUDE, charcoal and pastel on paper, 29" x 21" (73.7 x 53.3 cm).
Here Thomas used the bright, white drape and the intense black background to create a striking contrast with the figure. He made the interesting textures in the hair and background by applying a smooth layer of charcoal to the paper and then removing light lines with his eraser.

WHERE DO YOU
PUT THE SHADOWS?

SIMPLE SHADOW DRAWING

The charcoal drawing here shows where the five value areas fall on a simple sphere lit by a direct light source. The light is shining from the upper left; everything directly in its path, that is, the bright upper left section of the sphere, is the area of direct light. *Next to that is an area with slightly darker value; this area is created by* indirect light. *The shadowed edge* is the part of the sphere that is facing away from the light source; it is dark because no light is shining on it. The area of reflected light *would be as dark as the shadowed edge, except that in this area light is reflecting off other surfaces onto the sphere, making it brighter than the shadow area. The darkest value in the drawing is the* cast shadow; *this shadow is created by the sphere blocking the rays from the light source. Notice that the shape of the cast shadow is spherical here because it is cast onto a flat surface.*

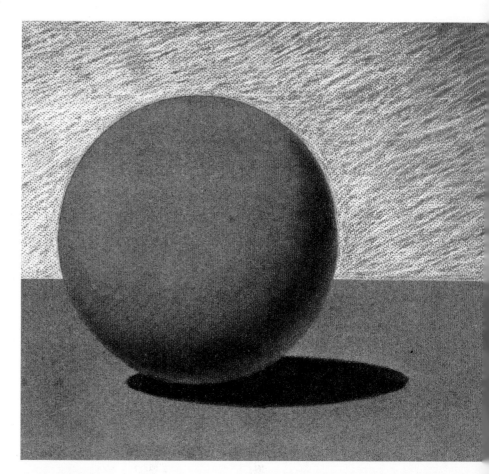

DISTORTED SHADOW DRAWING

This drawing illustrates how a cast shadow assumes the shape of the surface upon which it is cast. The light is directed onto the sphere from the upper right, so that the cast shadow falls on the left across the steplike, irregular surface behind the sphere. Notice that the shape of the cast shadow is influenced by the shape of the lighted object as well as contour of the surface upon which it is cast.

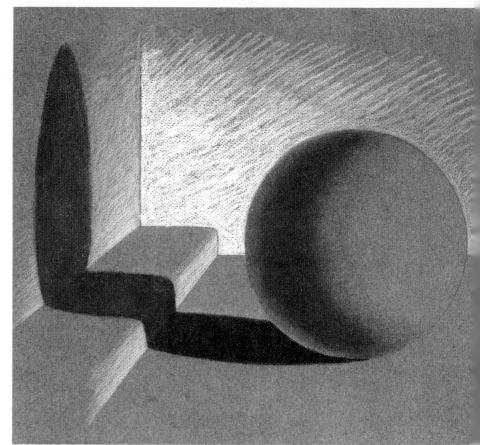

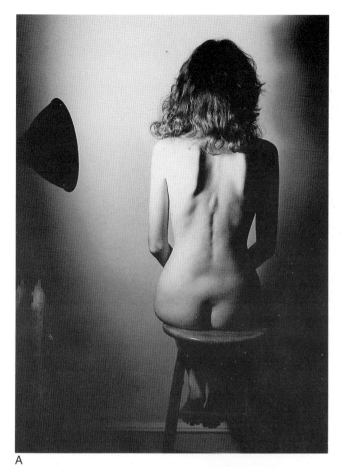

A

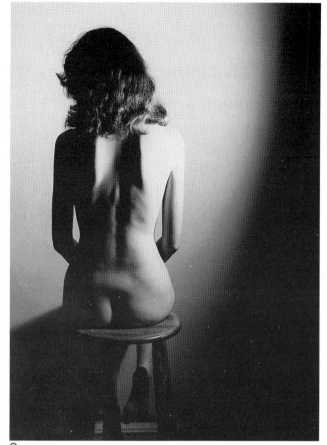

C

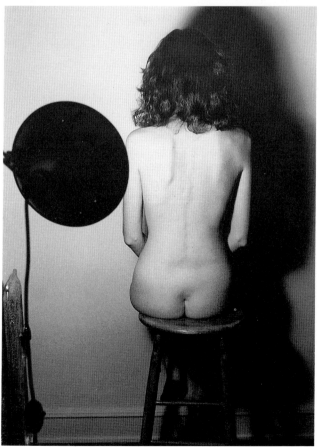

B

THREE LIGHT SOURCES

These photographs illustrate how the light source affects the values of the figure. When you move the light source, dramatic changes occur in the light and dark areas of the figure.

In photograph A, the spotlight is shining from the left; consequently, the brightest areas of the figure are also on the left, in the direct path of the light. This single light source shining from the side creates what Thomas calls a 1–2 division of values, where one side of the figure is light and the other is dark, with little variation in between.

In photograph B, the light source has been moved so that it shines almost directly onto the center of the model's back. Notice how this frontal light eliminates almost all shadows except for the dark areas around the outer contour of the figure. Because the back is all one value, it looks much flatter than the back of the same model with a side light.

In photograph C, the light has been moved to the side again, but now it is placed to the right. In this situation, the highlights are now on the right and the shadows on the left.

These examples show how very important it is to be deliberate in planning the light that shines on your model. You can make your figure look more or less rounded and your total drawing more or less dramatic just by manipulating the light that is shining on your model.

CAST SHADOWS

Cast shadows occur when an object interrupts the rays of light shining on another surface. Cast shadows are complicated in shape and value. They reflect the projected shape but are distorted by both the angle of the light and the surface on which it is cast. For example, the cast shadow of a round ball will rarely be round. The angle of light may make the shadow spherical, but if the shadow is cast onto an irregular surface, the shadow will be distorted.

The best way to determine the shape of a cast shadow is, again, to study your subject. Look at the shadow and notice how it reflects the original object and how it conforms to the surface on which it is cast.

The value of the cast shadow can vary from shadow to shadow and within the same shadow. Thomas thinks of the cast shadow as being one shade darker than the surrounding area. He draws the total area as it would be without the cast shadow, then adds the shadow as a transparent layer of value.

SHADOWS AND THE MALE FIGURE

Because of the musculature, Thomas sees the male figure as angular and architectural, in contrast to the fluidity of the female form. Consequently, the shadows in the male are more angular and rigid. However, the process for shading the male figure is the same as the female.

EXPRESSION THROUGH SHADING

For Bob Thomas there must be a reason for every figure drawing. Just to practice for the end result of improving his technical skill isn't enough. Each drawing must be a statement of his sensitivities to the model, to the lighting, and to the medium. It is the act of drawing that Thomas loves, that process of searching for the figure that will appear on the paper. He expresses this love in his patient rendering of the lights and shadows, using those sensitivities and skills to make each figure grow as a solid, breathing person.

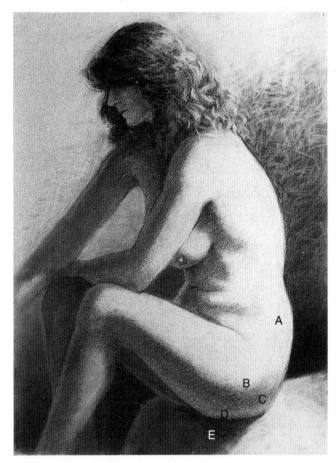

VALUE STUDY
In the hip and thigh area of this model, you can see the same value distinctions that are apparent in the drawings of simple spheres. Here, the hip itself is where the light is shining, creating an area of direct light (A). *As the hip curves around, away from the light source, we see* indirect light (B). *The* shadowed edge (C) *occurs on the underside of the thigh, where no light shines on the hip;* reflected light (D) *falls on the lower edge of the thigh; and the* cast shadow (E) *falls just beneath the thigh and leg.*

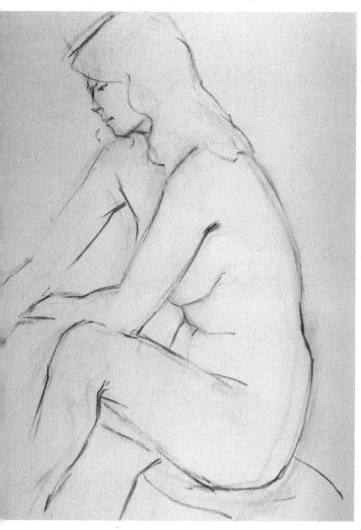

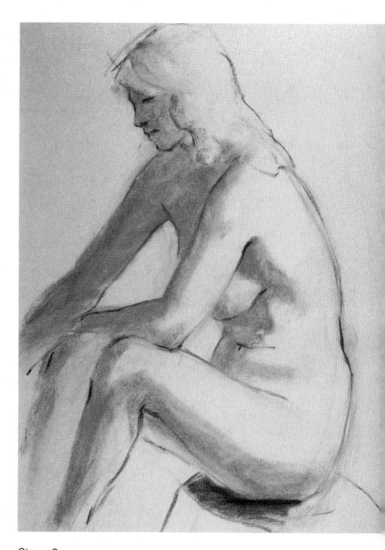

Stage 1
Thomas draws contour lines in vine charcoal to indicate the basic shapes of the figure. The rubbed-out lines show his process of searching for the figure. The line through the front of the face helps establish the angle or gesture of the head.

Stage 2
Here Thomas establishes his basic 1–2 division of light and dark. The light is shining onto the model from the right side; so the right side is light and the left is shaded. He also begins to establish shadows in the background, under the model. At this stage, Thomas is still working with vine charcoal, keeping everything light enough to make changes. He draws in the shadows with the side of the charcoal and blends them with a rag.

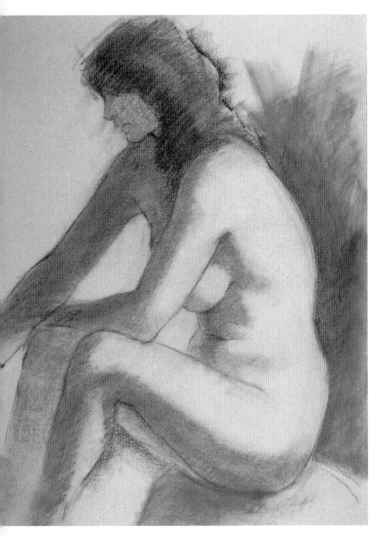

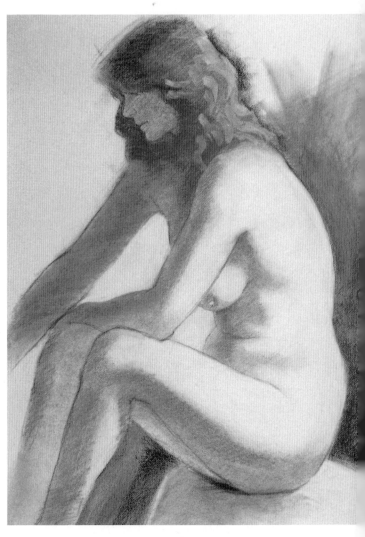

Stage 3
Thomas begins to be more specific here, adding definition within the dark areas. Notice the reflected light indicated in the left of the abdomen and in the leg. Thomas now divides the hair into smaller shapes and refines the contour lines. He also darkens the background so that the back of the figure is indicated more by contrast than line. At this stage, he introduces compressed charcoal, a more permanent medium than vine charcoal, in the hair and some of the contour lines.

Stage 4
Proceeding from the general to the specific, Thomas adds details in the hair, face, breast areas. He is relying more now on value than line to establish shapes, which can be seen in the contour of the model's face and the highlight along her left shoulder and upper arm. His primary medium is now compressed charcoal.

(right) Stage 5
In the final stage of the drawing, Thomas makes several changes for the sake of the composition; he changes the shape of the stool and the direction of the model's right leg, and adds a highlight to her right forearm. He then develops a texture to the hair and the background that results in a greater unity between the model and environment. For the darkest darks he uses a black Alphacolor stick; for highlights he erases areas with a kneaded eraser.

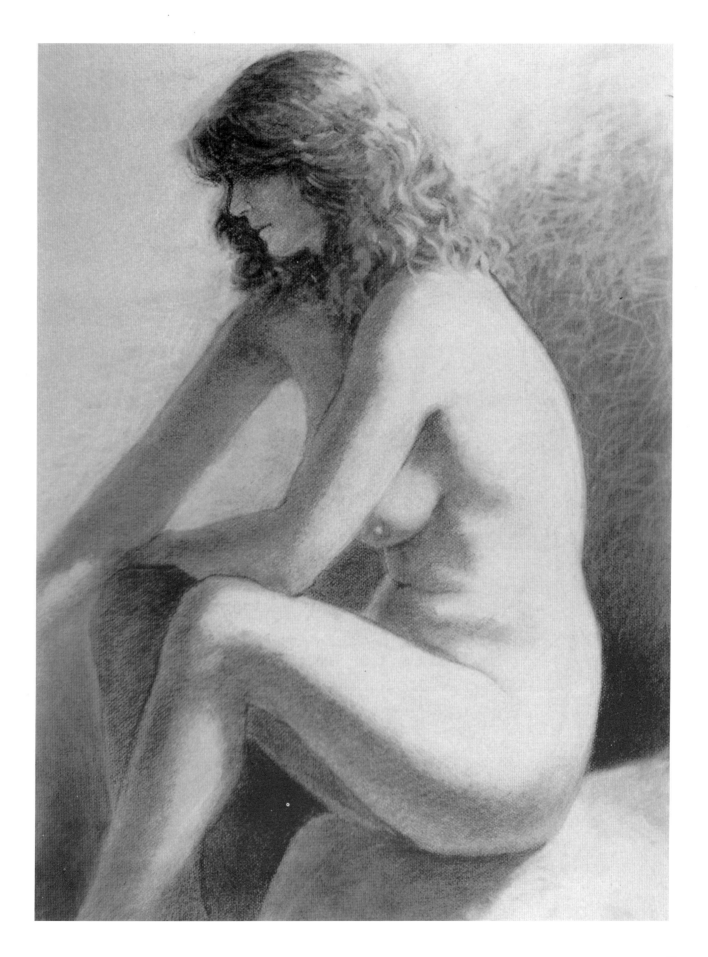

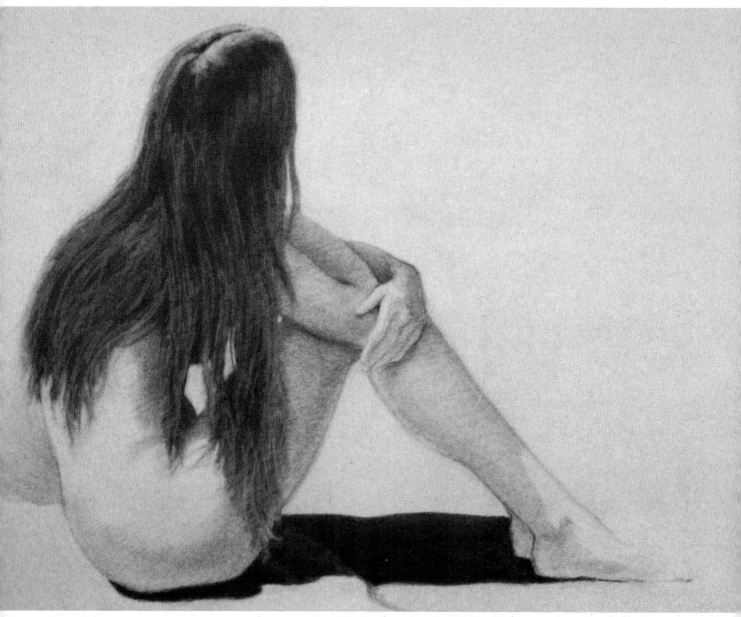

HAIR, charcoal on paper, 21″ x 29″ (53.3 x 73.7 cm).
*In this drawing the light is shining from the upper left.
Thomas is using the figure and shadows here to create
strong abstract shapes. Look at the pure shape created by
the total body. Notice the triangle formed by the legs and
cast shadow, and the small, interesting shapes created in
the negative space by the hair.*

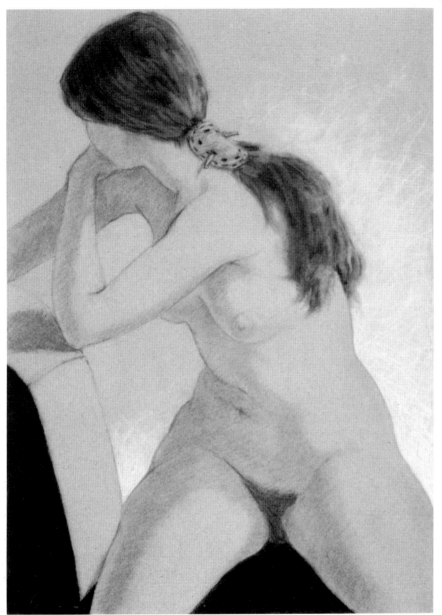

PONY TAIL, charcoal and pastel on paper, 29" x 21" (73.7 x 53.3 cm).
The focus of this drawing is the twisted torso. The model is a young woman with soft, rounded forms; the pose adds a needed tension to the drawing. Thomas delicately indicated the subtle shapes of the twisted abdomen with shadows and fine contour lines. Notice that the light falls on only parts of the figure; this fragmented light makes the tension of the pose more dramatic.

ASSIGNMENT

Place your model in a very simple pose and shine a single spotlight on the figure from the side. The figure should appear to be divided into a light side and a dark side, as in Bob Thomas's 1–2 Approach. With white pastel or white Conté crayon and a sheet of black paper, draw all the areas of the figure where the light is shining on the body. You basically will be drawing only one side of the model, but if you draw it accurately, the figure will appear to be solid.

Now do a second drawing of the same pose with the same light. This time use charcoal or black Conté crayon on white paper. Now draw only the shadowed areas of the figure.

By comparing the two drawings, you will see that you can create a solid portrayal of the figure either by drawing the light or the shadow.

Note: No matter how little light you shine on the model, be sure that you have enough light on your paper to see subtle gradations of value in your drawing.

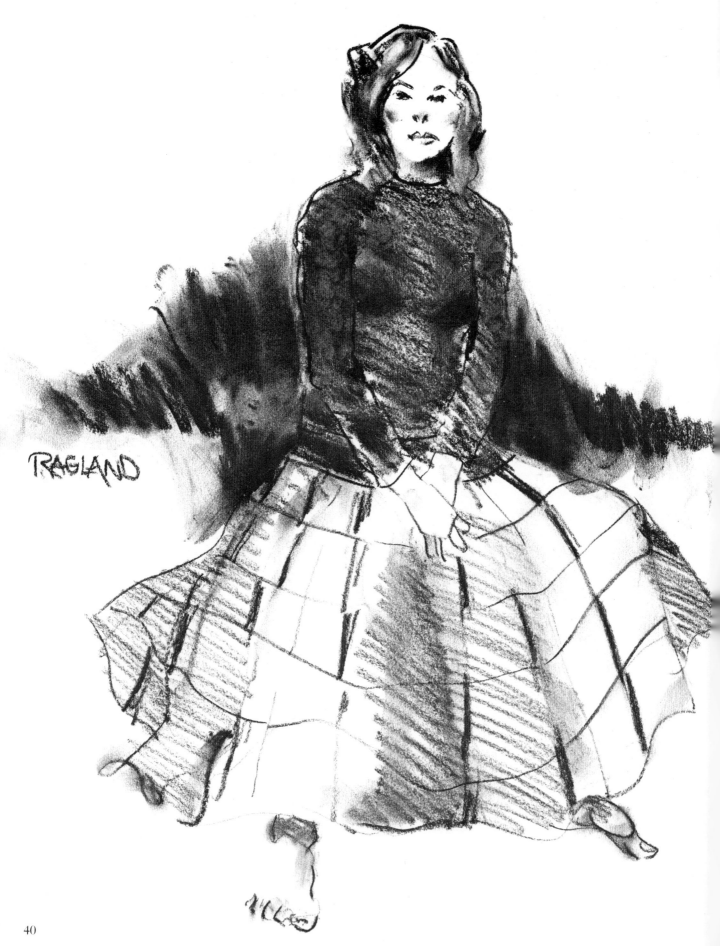

RAGLAND

3 ALL ABOUT MODELS

Bob Ragland

Bob Ragland is a "people person;" in his art and his leisure, he is surrounded by people. He explains, "I've drawn people all my life. I think of it as recording history, standing on the corner drawing the people who go by."

Because a figure drawing is an expression of the model, the model always has a great effect on the work. For that reason Ragland is very careful of the models he selects to work with. He says, "In order to do a good drawing of a person, you have to have a love for that person, not a romantic love, but a caring about who that person is."

WHAT MAKES A GOOD MODEL?

At first Ragland used to ask everyone he knew to pose, but over the years he has become selective. There are three qualities he seeks in a model:
1. attractive or unusual appearance
2. interesting personality
3. good attitude

In regard to appearance he doesn't limit himself to pretty, young women. He likes drawing all sorts of people—young and old, fat and thin, male and female.

There was a seventy-seven-year-old man who inspired a whole series of drawings that Ragland calls *The Gleaners*. Ragland lives in the inner city and devotes many hours every week to wandering the city by car or foot. He saw this particular old man walking through the alleys collecting aluminum cans from trash barrels. The man was dressed in a formal shirt buttoned to the collar, a shabby jacket and slacks that barely reached his ankles, showing a pair of green, high-topped sneakers. After watching the man for a while, Ragland approached him casually and asked, "Do you mind if I walk with you?"

For two days the old man and the artist walked five miles a day, the old man picking up cans and the artist making sketches. Why did Ragland pick this particular person to draw?

Ragland says, "I liked the way he looked and he had a nice, easygoing personality, but mostly it was because he had a lot of dignity. There is something special about old people who have a lot of dignity."

When he works with the traditional female nude model, he doesn't look for a "*Playboy* beauty." He usually chooses large, full-figured women, explaining that large women give him a chance to work with volumes and masses.

PERSONALITY

The second element of a good model is personality. Ragland says he is not drawing the appearance of a person—he is drawing the person. The model must be someone who is interesting to talk with as well as to look at. He prefers models with character, with experience of the world.

Ragland says it is important to take the time to

CHECKED SKIRT, charcoal on paper, 22″ × 17″ (55.9 × 43.2 cm).
Ragland thinks that clothing should be appropriate to the model and also enhance the design of the drawing. This wide, checkered skirt works well here with the drawing's overall pattern of dark and light. Notice that in this pose the knees are placed wide apart; this shows off the skirt and also conveys a sense of confident relaxation.

get to know the individual. One of his favorite models was a woman who drove a school bus. He smiles as he describes how she'd chat during a modeling session, "She'd sit there smoking a cigarette and drinking her wine and she'd tell me what happened during the day, 'Those little kids tried to get on my nerves, but I showed them who's boss.' "

ATTITUDE

Ragland looks for a pleasing disposition in models, someone who is on time, doesn't mind posing as long as he needs him to, and someone who realizes that drawing is a serious thing. If he asks someone to model and they are negative in any way, he won't take them on—no matter what they look like.

Often, Ragland will draw someone who is an artist, like a painter or a dancer. To Ragland, they have a greater understanding of what he does, so there's a special rapport between the model and him.

Sometimes a good model will show up in a bad mood. Ragland says, "I give the model a glass of wine or coffee and I do some therapy. 'You don't look happy,' I'll say. 'What happened? Do you want to talk about it?' I've had many a model sit there and cry and tell me his or her problems. I don't mind. It develops a closeness and that makes for better drawings."

Ragland is not concerned about whether a subject has had previous modeling experience. He has found that inexperienced models are often nervous, but they can also be more enthusiastic and more eager to please the artist.

WHERE DO YOU FIND MODELS?

If you think of potential models as anyone who looks interesting enough to draw, you can find models anywhere. Ragland has found models in shops, restaurants, classrooms, and even, as in the case of the old man, alleys. However, approaching a model can be an awkward situation for both the artist and the model. Ragland's advice is to be as professional as possible when you ask someone to pose for you.

The easiest conditions for meeting models will often be found in art-related situations, such as a painting class or drawing session. In other situations, Ragland establishes his credibility as a professional artist. He introduces himself to the prospective model and presents a business card or brochure about his art, explaining that he often draws live models and that the person looks like someone he would enjoy drawing.

One of Ragland's models was a flamboyant young woman who had never modeled before. He met her in a bookstore where she worked. She said to him one day, "You sure buy a lot of art books."

He explained that he was an artist and asked if she would be interested in modeling. He gave her his card and she called him three days later.

"Lots of people are flattered when I ask them to model," Ragland says. "Some just think I'm a lecher, but I still ask anyone who looks interesting."

From the beginning it is important to establish when and where you want the person to model, whether the model will be nude or clothed and how much the model is to be paid. Always be sure that both you and the model understand and agree on all the conditions.

FINDING THE RIGHT POSE

"The first session I have with any model is for warming up," Ragland says. "We sit and talk for a few minutes before we start. Then we do lots of simple poses, three to five minutes each. I always make sure that the model is comfortable. If she's not comfortable, then I'm not comfortable and it shows in the drawing."

A good pose is any pose that you enjoy drawing. Ragland suggests that when you start out, you should draw the poses that are easiest for you. If you enjoy standing poses, draw standing poses from all directions.

Ragland doesn't like formal, academic poses. He prefers those that are natural to the model. During the beginning of each session, when he and the model are chatting, he never takes his eyes off the model, looking for the subtle nuances of attitude that will make a great pose. Often the model will unconsciously assume the best poses.

The length of the pose should be determined by the intricacy of the drawing and the comfort of the model. The model should not be expected to hold a pose that is painful; besides basic respect for the model, the model's discomfort will cause the drawing to be stiff and awkward. If you must have an extended time on a difficult pose, give the model frequent breaks to rest and stretch.

It is advisable to use an automatic timer so that you can be aware of the lapsed time of each pose. During a long pose, periodically compare the model to your drawing so that you can make adjustments if the model has moved.

BATHER, charcoal on paper, 22″ × 17″
(55.9 × 43.2 cm).
This model, Barbara, was a ballet dancer. Ragland enjoyed drawing her because of her strong, muscular body and her long hair. There is a tendency in beginning artists to always pose the figure with the face showing. Here, Ragland turned the model's head away because he wanted to draw her hair. Even without the face, however, it is a personal, intimate drawing.

HALF DRESSED, crayon on paper, 23″ × 17″
(58.4 × 43.2 cm).
This is a sketch Ragland made as Sam was changing her costume. It was done very fast, in one minute or less. Ragland advises artists to practice gesture drawings, and to ask models to change positions as quickly as every fifteen to thirty seconds. By forcing yourself to see and record poses in such short times, he believes that eye-hand coordination is greatly improved.

ALL ABOUT
MODELS

1. LOUNGING, crayon on paper, 23″ × 17″
(58.4 × 43.2 cm).
In this drawing Ragland has caught Sam at rest, seated during a break between poses. The upper body is a squarish mass. He makes the pose appear more feminine by placing the legs in a graceful, crossed position.

2. SAM WITH RUFFLES, crayon on paper, 23″ × 17″
(58.4 × 43.2 cm).
Sam was a salesgirl Ragland met in a bookstore. In this particular pose she has taken an aggressive stance, which is made evident by the widely set legs, the hands on hips, and a cocky turn of the head. Ragland says that not only do models differ from each other, but they also change from session to session and even during the course of one drawing session. He likes to draw many quick sketches of each model so that he can capture these changing moods.

3. BLACK STOCKINGS, crayon on paper, 23″ × 17″
(58.4 × 43.2 cm).
Here Sam is standing in a shy, awkward pose. The artist has simplified and rounded the basic shape of her body to make her look plumper, more solid. By using thicker, less graceful lines, he has established those same qualities in the figure. Here he is drawing with crayon. Notice how he uses the side of the crayon to establish the middle-gray values.

4. DENISE WITH SHAWL, charcoal on paper, 22″ × 17″
(55.9 × 43.2 cm).
Ragland uses costumes only when they work well with a particular model. With this black model and two pieces of fabric, he was able to create an African mood. Notice how he has posed the model with the weight on one foot and the other one tilted up. This stance creates an interesting line within the figure as well as suggesting a feeling of motion.

5. ANITA, charcoal on paper, 24″ × 17″
(61 × 43.2 cm).
This drawing is of one of the large, full-figured models that Ragland typically likes to draw. Notice the playfulness of the line in this sketch; Ragland is more concerned with the whimsical, rhythmic quality of the line than with a faithful rendering of the figure.

6. DENISE, charcoal on paper, 22″ × 17″
(55.9 × 43.2 cm).
Denise, a young woman Ragland met through friends, had never modeled before. He says that when a model is awkward about posing nude, he will draw her partially clothed or draped first. Here he poses Denise modestly holding a piece of fabric in front of her body. This prop works well with the shy gesture of the head tilted forward.

1

4

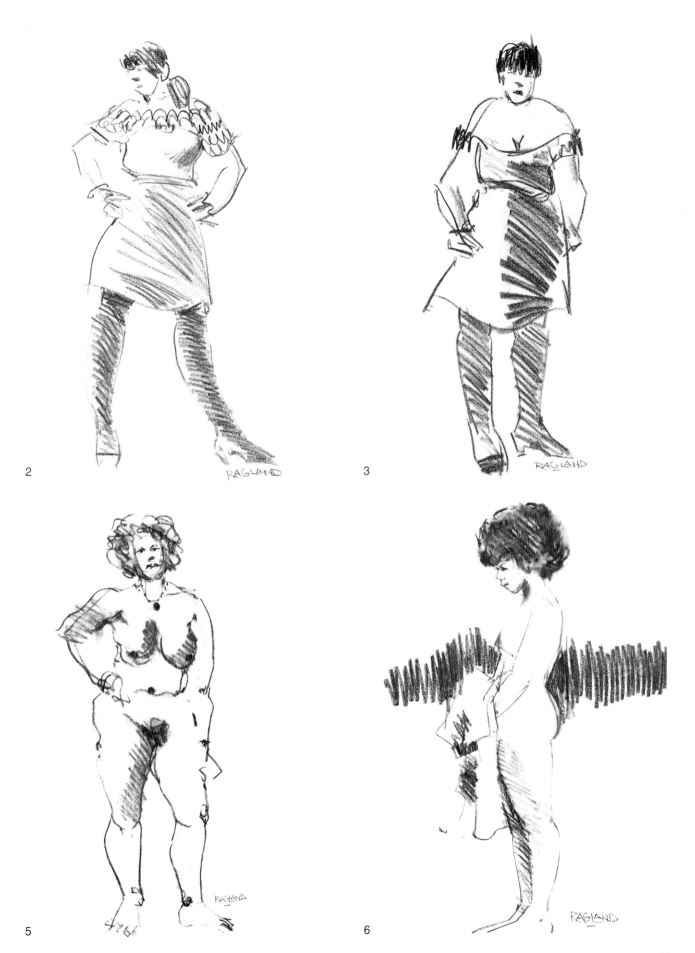

2

3

5

6

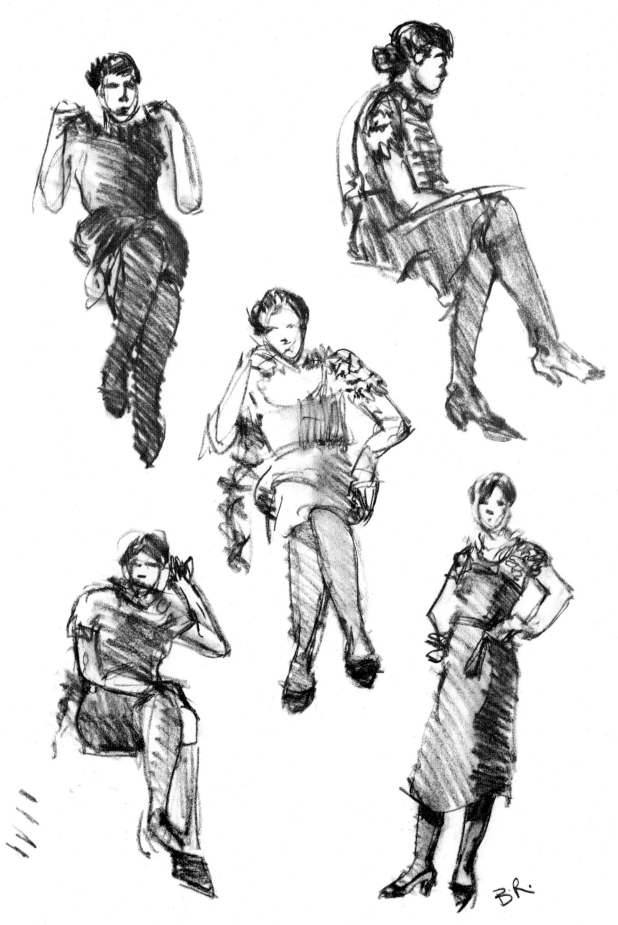

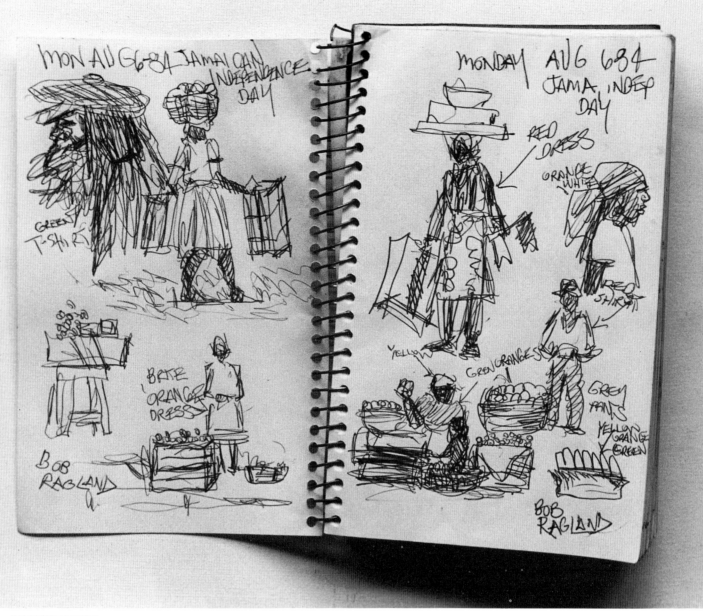

SKETCHBOOK

These are two typical pages from a sketchbook Ragland
kept during a painting trip to Jamaica. He records quick
impressions of gestures, costumes, and props, and makes
notes about colors, all to be used in future drawings and
paintings. He believes it is important to draw constantly, both
to develop your eye and to refine your drawing skills.

(left) STUDIES OF SAM, charcoal on paper, 33″ × 21″
(83.8 × 53.3 cm).
*This is a group of very quick sketches of the same model.
Ragland says he likes to begin a drawing session with a
series of short poses so that both he and the model can
warm up. These sketches show how he explores the natural
gestures of a model. Here, he has asked Sam to assume a
number of sitting poses in which she just slightly alters her
position. Notice the simple changes in arm placement.*

*When he is working quickly, Ragland often draws several
poses on one sheet of paper. By doing so, he can maintain
more momentum in his drawing simply because he doesn't
have to stop and change paper.*

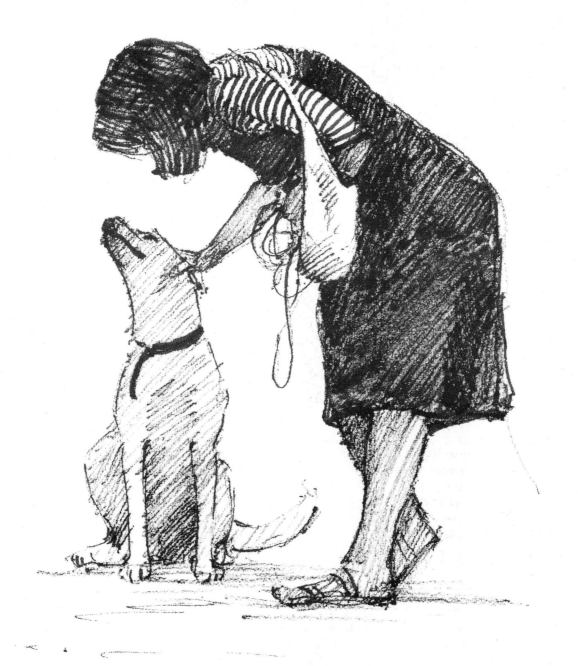

BEST FRIENDS, pen and ink on paper, 5¼″ × 8½″
(12.8 × 21.6 cm).
*This woman is petting her dog, and the dog looks like he's
loving it. The gesture suggests that the woman is talking to
the dog; and the attitude of the dog's head tells us he is
listening attentively. Notice that the woman's body curves
around the dog, which makes the two of them one shape;
this adds to the sense of intimacy in the drawing.*

4 LEARNING TO DRAW BODY LANGUAGE

Kim English

Kim English enjoys drawing people enjoying life. Wherever people are rollerskating, walking their dogs, or just sitting in the sun in the park, English can be found sketching, painting, or photographing the crowd. His work shows unselfconscious people, relaxed and comfortable.

English's drawings are peaceful, gentle, and unselfconscious, just like his subjects; and the reason they work so well is that he is adept at capturing gesture. Look at the sketch he has made on the facing page of a young woman petting her dog. Her body is bent in a movement of friendly intimacy. One hand rests lightly on the dog's head; the other holds the leash. You truly believe that this is a woman sharing a special moment with her dog.

The gesture of a figure is the expression of the figure's action or lack of action. The gesture shows the attitude of the subject toward the world. If there is more than one figure, the gesture shows the attitude of the figures toward each other.

CAPTURING GESTURE

English's ability to capture gesture is a result of three activities. English not only knows, but teaches human anatomy. He says that understanding how a body moves and fits together is only possible when you have a basic knowledge of muscles and bones. He studied anatomy in classes and books and suggests that any serious artist do the same.

The second is an ongoing activity—that is, English's constant observation of people. He watches with a concern for the lines and shapes that convey movement and attitude.

The third activity is drawing—drawing constantly. Whether in formal paintings or simple sketches, English is always recording his impressions of people. He looks at a gesture, quickly draws it, and then analyzes the drawing to see if he has, in fact, captured the gesture. Only through hours and hours of observing and drawing is English able to create those simple renderings that look so effortless and so real.

THE PROCESS OF DRAWING

English says, "I try to look at the whole figure at once, trying to see the total shape of the person. I draw a general shape that will encompass the figure from head to elbow to knee to foot. I leave it loose so that I don't get caught up in the outline, that magic string around the figure that students get locked into. I try not to think too much about the outline. I don't immediately draw the outer edge of the figure; I sneak up on it."

He strives to get down the total figure, working back and forth, constantly comparing one part to another so that he can maintain accurate proportions and angles. He uses the spine to tie together the three main masses—the head, ribcage, and pelvis. He uses other bones, elbows, knees, etc., as landmarks to place the limbs.

English places the center of the body. Then he locates the extremities of head, hands, and feet, working back and forth to connect them. He reworks until he has captured not only the anatomy, but also the gesture, the language of the body that says what is really going on.

GESTURE DRAWINGS

1. *This child is sitting alone in a doorway. His head bent forward to the knees, upper torso curled in upon itself, arms drawn inward, and face hidden all express a feeling of isolation and solitude.*

2. *This scene conveys a much less intimate situation than the one shown on page 48. The man is looking off to the side rather than at the dog, and both figures are in motion.*

3. *This was a man looking at a display at the Denver People's Fair. His gesture suggests that he is interested, but that he doesn't want to buy anything.He's leaning slightly forward with his head and shoulders twisted toward the exhibit—interest. His arms are crossed and his feet are planted firmly, pointed away from the exhibit—resistance.*

4. *This girl is moving faster than the figure of the man above. Her body has more angles and is less vertical. The girl's arms are thrust back and she is looking where she is going; both indicate forward motion.*

5. *The gesture of this pose shows the relationship between father and child. The father's body is creating a cocoon around the child, offering protection and support.*

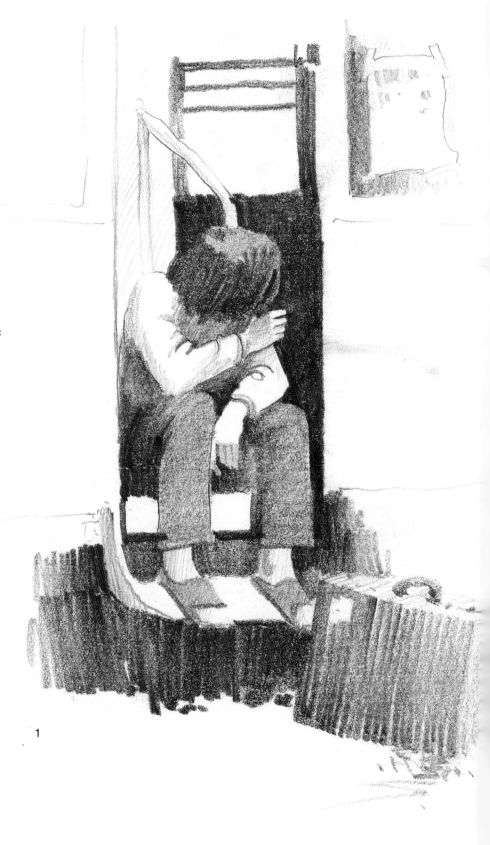

1

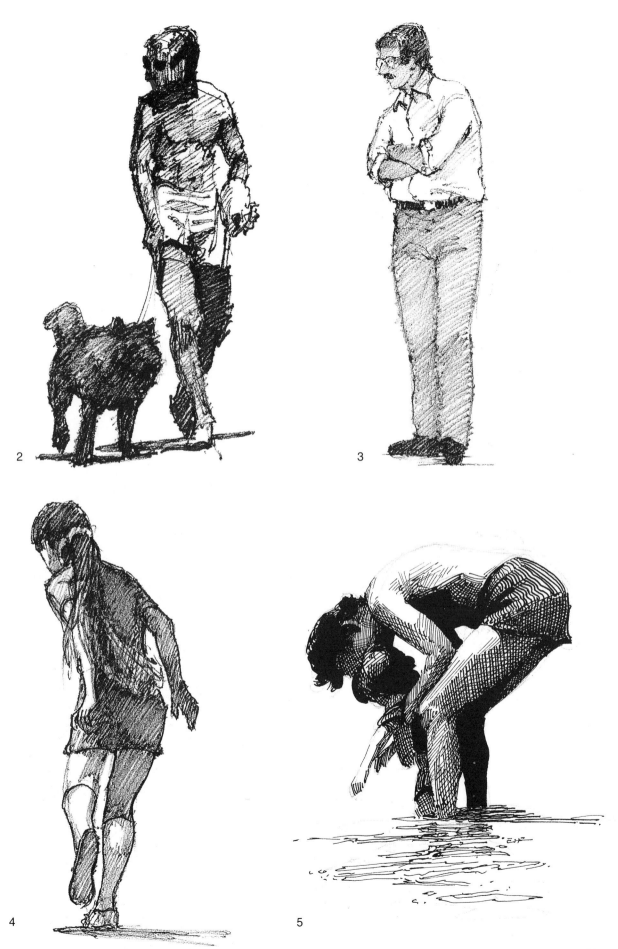

2

3

4

5

51

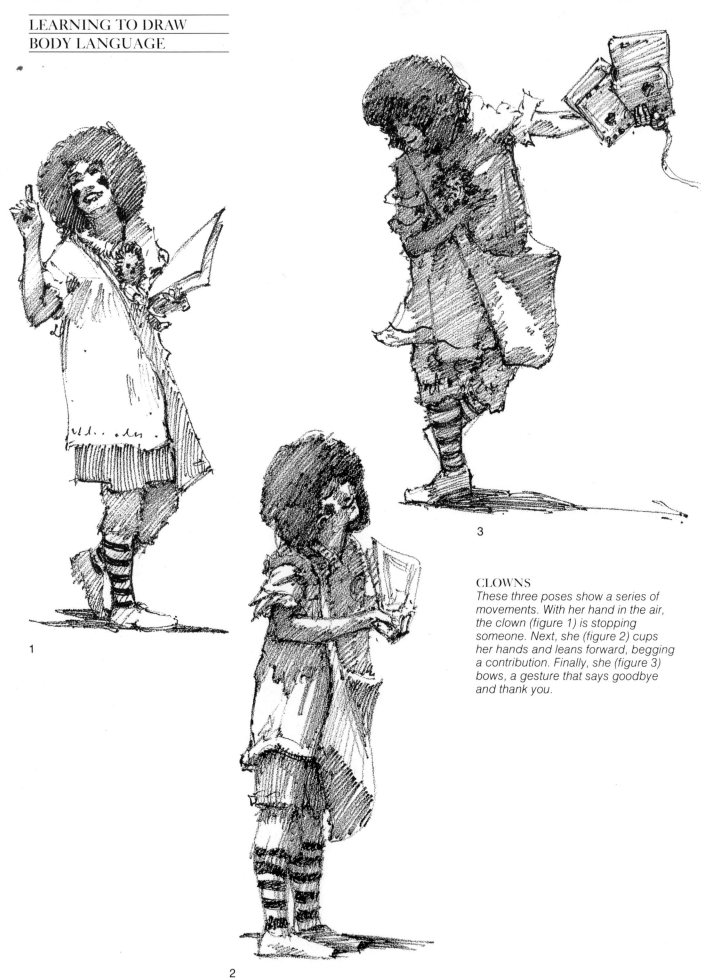

3

1

2

CLOWNS
These three poses show a series of movements. With her hand in the air, the clown (figure 1) is stopping someone. Next, she (figure 2) cups her hands and leans forward, begging a contribution. Finally, she (figure 3) bows, a gesture that says goodbye and thank you.

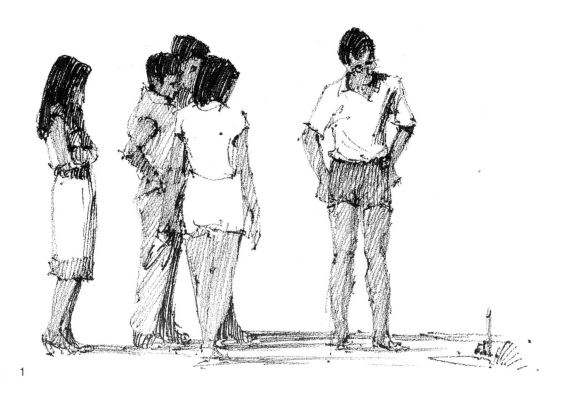

1

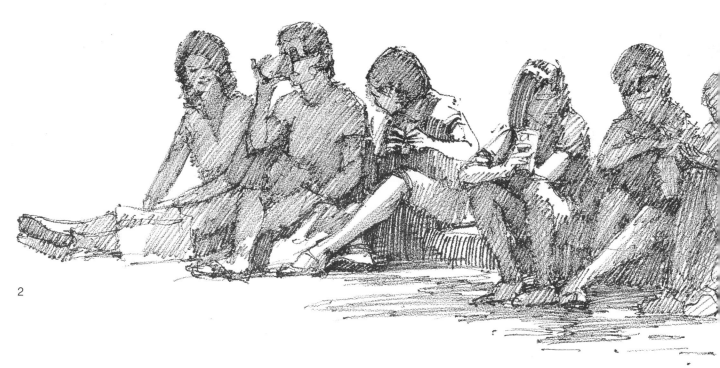

2

GROUPS OF PEOPLE

Even though these people (figure 1) are not all standing close to each other, there is a unity to the group because they are all looking in the same direction. They all appear to be noticing something outside of the group itself.

In figure 2, English has recorded the gestures of a group of young people sitting on a sidewalk. He says he was concerned with the surprising amount of activity that can be seen in seated figures. Notice the different directions the legs are pointing, the various angles of the arms, and the assorted placement of the heads. This is the kind of movement within a drawing that gives it strong visual interest.

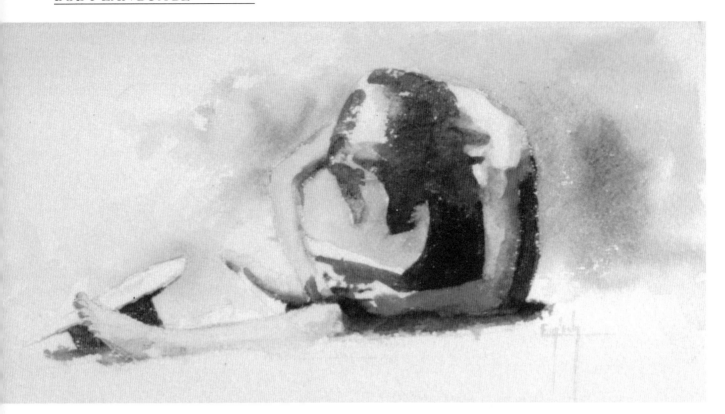

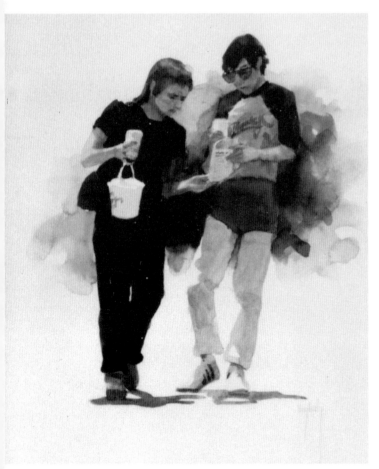

(above) BEE STING, watercolor on paper, 8 " × 16"
(20.3 × 40.6 cm).
*The girl is concentrating totally on her foot. Her back and
arms make a circle encompassing the one foot, thereby
focusing the viewer's attention on that foot. English has left
most of the background light. This makes the dark area more
important, which emphasizes even more the gesture of the
drawing.*

*English uses his sketchbooks to plan out elements of
composition for future works. In the sketch above, he
indicates the position and gesture of the figure, the division
of negative space, and the placement of light and dark
values. English knows that if a composition or gesture is not
interesting in such a small version, it probably will not work
well in a larger drawing or painting.*

NEWS, watercolor on paper, 14 " × 10" (35.6 × 25.4 cm).
*The boy is showing the woman something he has just read.
He has already read it; so he is standing up straighter, not
quite as involved. They are both focused on the newspaper,
but they are walking at the same time. The motion is es-
tablished by the shape and position of the legs.*

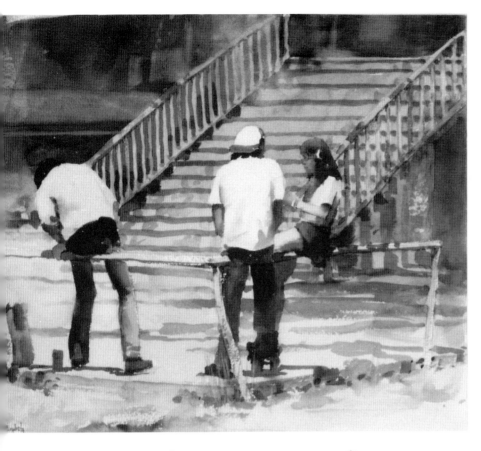

One of the skills necessary for capturing gesture is the ability to draw fast. The only way to achieve this speed is to practice. When you are watching television, keep a sketchpad and pencil in your lap. Begin by looking at the people as they move on the screen. (Don't draw yet.) Ignore their facial features and details of clothing; concentrate only on the position of the body, the angles of the torso and limbs. Try to feel the movement of the television figure in your own body. If the figure on the screen moves a leg, feel it in your own leg.

After five minutes of just looking at the gestures, you can begin to draw. Draw twenty-five gestures at a time. Use fast, flowing lines. Remember, you are not trying to capture details, but to show the most important positions and movement of the total body.

Work from television figures until your drawings begin to convey a sense of the gesture. You should be able to go back to any gesture drawing several days or even weeks later, and, just by looking at the sketch, you should be able to recall the entire gesture.

After you are comfortable drawing gestures from television, take your sketchbook into public places where you can draw real people as they move. Start with places where people sit, like restaurants and bars. As your drawings get faster, try to capture people walking, dancing, playing ball, etc.

RED SKATES, watercolor on paper, 12″ × 15″ (30.5 × 38.1 cm).

There are three figures in this composition, but English has divided them into a couple and a separate figure. Placement affects the design, but it also helps to define the interpersonal relationships. The artist has created an intimacy between the couple by placing them so closely that they become one shape. The third figure is separated by space and also by the gesture of leaning away from the others.

In the sketch above you can see how English begins to work out the gestures and values for a finished composition. This is a simple diagram where he has loosely indicated the background and concentrated more on the placement of the figures and their gestures.

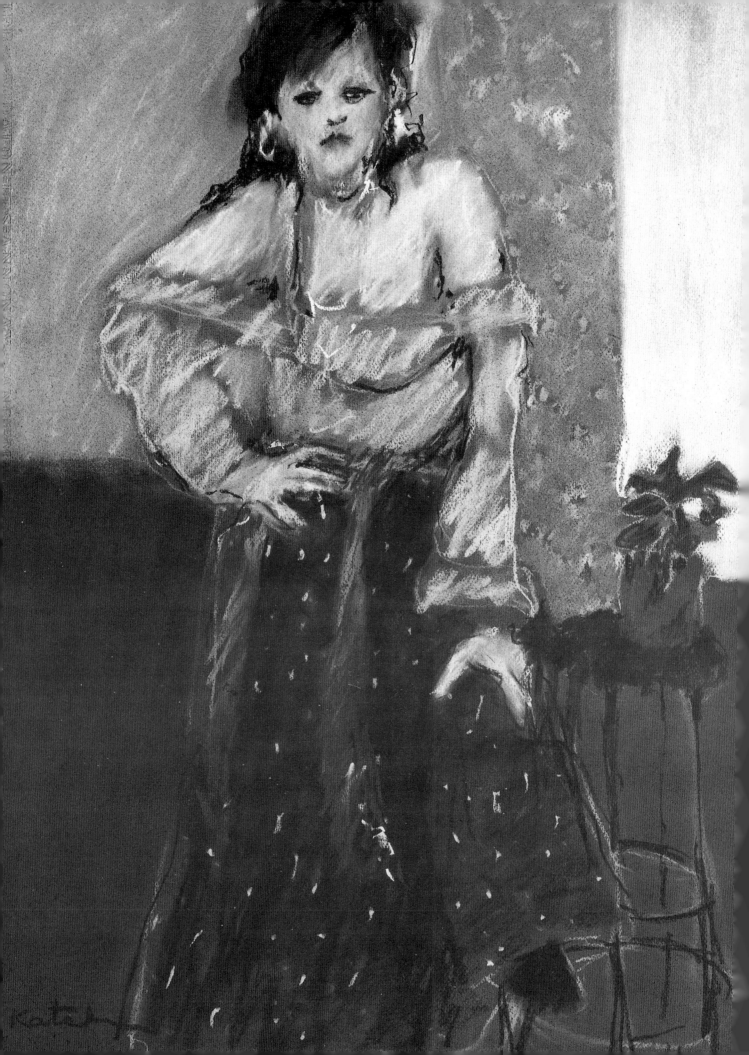

5 COMPOSING WITH THE FIGURE

Carole Katchen

I have found that whenever I can't make a drawing work, no matter what I try, it's because there is a problem in the basic composition. I can change color and value all day, but if the relationship of shapes within the drawing is bad, nothing will save the piece. So I have learned that the first thing to consider in a drawing is the basic composition or design.

Composition is how the total drawing fits together, the relationship of all the parts. Composing a drawing is a matter of dividing the total space into various shapes. In the best drawings, the size and arrangement of those shapes provide a focal point, a sense of balance, rhythm, movement, and tension.

There are some artists who design their space in a random, haphazard manner, trusting that somehow the drawing will all come together in the end. Sometimes it works and sometimes it doesn't. I recommend that an artist take the time to plan the composition as the first step of a drawing. If the drawing is well designed, then all the other elements, line, value, etc., will be even stronger.

THE SHAPE OF THE FIGURE

The first consideration in planning your composition is the shape of the figure. By shape I mean the outside contour of the body. When I pose a model, my initial concern is for the total shape created by the pose. The round, compact shape created by a curled-up model is vastly different from the starlike shape of a model with all limbs extended. In a good composition the shape of the figure will be interesting from any direction. Turn your drawing upside down or on its side to see if it maintains its interest.

Even with the simplest forms you can make the shapes more interesting by using a sensitive contour line. Rather than drawing a simple, smooth, curved line for the back and shoulders of a rounded pose, look instead for the subtle variations in shape created by the bones and muscles. Attention to detail makes a more interesting composition out of what might otherwise be a lifeless oval shape. Another way of giving basic shapes more interest is by using costumes or

GYPSY REFLECTIONS, pastel on paper, 25″ × 19″ (48.2 × 63.5 cm).
In this drawing the standing figure divides the composition into three vertical shapes of similar size. This creates the basic balance. The composition is made less static, however, by the movement in the pose: the bent, jutting elbow and the raised knee that make the contour of the figure more interesting. Another element that adds to the complexity of the composition is the division of the negative space into shapes of varied size and value. Notice how the legs of the stool and the leaves of the plant break up the background areas to the right.

props. A hat can extend the contour of the head; a chair can be incorporated into the total shape of the figure.

THE SHAPE OF THE GROUND

The shape of the figure will necessarily affect the shape of the background, and that is the second consideration of a well-designed composition. The simplest composition consists of two basic shapes—the figure and the ground (or the negative space). Negative space is everything that surrounds the figure, and when you plan a drawing, the negative space is just as important as the figure.

When an artist first begins to draw the figure, it is natural to focus on the figure, ignoring everything else. However, in the long run, it is a mistake to disregard the negative space because this space helps to define the figure. In fact, you can create a strong sense of the body just by drawing what is outside it. Thus negative space can give the figure a feeling of reality, by placing the figure in a real environment. It establishes the three-dimensional quality of space and can also create the mood or tone of the drawing.

I always try to think of negative space as a shape itself, without regard for the figure. Usually if the figure has an interesting shape, the negative space will be interesting as well, but this isn't always the case. You must consider each shape by itself.

FRAGMENTED NEGATIVE SPACE

The simplest composition is one with two solid shapes, the figure and the ground. Either the figure is floating in the negative space—that is, the figure is completely surrounded by space—or the figure is resting against one side of the edge of the paper.

These two alternatives are the simplest way to design a drawing, but they are not necessarily the most interesting. A more interesting composition usually results when you divide the negative space into several shapes, which is what I refer to as a "fragmented ground." A good example of how the figure can divide the ground into many shapes can be found in the drawing *Nudist* (page 62). Another way you can break up the negative space is by using more than one figure in the composition.

THE RELATIONSHIP OF SHAPES

The next point to consider in composition is how do the shapes of the figure and ground relate to each other. This relationship is important not only for its purely visual effect, in terms of providing balance and visual interest, but also because it can

also establish the meaning of a drawing. For instance, if the figure is so large that it leaves very little negative space, it suggests that the person is of maximum importance; whereas, if the ground is much larger than the figure, the person tends to lose importance.

If the figure is placed against the top of the paper, with a large space left at the bottom, it will appear to be floating in space, an unstable object in the drawing. If the figure is set on the bottom of the paper, leaving more space at the top, the negative top space will look like it is pushing down on the figure.

SHAPES WITHIN SHAPES

After you establish the large basic shapes of the composition, the next step will be to subdivide those shapes. In planning the smaller shapes, keep in mind variety and repetition. The relationship between the larger shapes gives your composition its basic strength; the smaller shapes provide visual interest.

Window Light (page 66) provides a good example of how the division of the negative space can enhance a composition. The shapes of the windows and the light they cast provide a repetition of shape that adds drama to the total piece. The patterns are interesting in themselves, but their rectilinear shapes also create a strong contrast with the organic contours of the figure.

FOCAL POINT

A good composition has a strong focal point. This is the spot in the drawing that immediately attracts the eye of the viewer. In a drawing of one figure, the focal point is often the face or just the eyes of the model. This is most dramatic when the model is drawn looking directly at the viewer creating a personal confrontation.

The focal point in a figure drawing doesn't always have to be the face of the model; it can be any interesting part of the figure or even the background. One way to create a focal point is with dramatic contrast of line, value, or color in one part of the drawing. In a drawing of the back of a figure, for example, a focal point can be established by placing a bright highlight on one of the contours of the figure and juxtaposing that with a dark background. That contrast of bright light on the hip or shoulder set against a very dark ground will immediately draw the eye of the viewer.

I once heard that most readers are lazy, and it is the job of the writer to make them want to read. I think the same is true for artists. Most viewers

would rather not look at much of anything; it is our job as artists to catch their attention and make them see what we have done. A strong focal point will help to accomplish this. The artist is not always available to grab the viewer by the elbow and pull him over to look at the drawing. By including a bit of drama in every drawing, the work itself will attract the viewer.

BALANCE

Balance in a drawing is the same as any other type of balance; it is a sense of stability, often symmetry, that provides comfort and ease. When a piece of artwork is unbalanced, it creates the same sensation as when your body is out of balance—it gives the feeling that at any moment it might topple over.

Balance doesn't refer only to the pose of the model. The figure can be standing firmly on both feet as immobile as the Eiffel Tower, but if the abstract shapes of the drawing are not designed well, the drawing can be unbalanced. An unbalanced drawing might be one with a large empty space on one side of the figure and nothing on the other side, or a drawing where the figure appears squeezed into one small corner of the paper.

The best way to determine if a drawing is balanced is to look at it in terms of abstract shapes. Look at the drawing in a mirror, or squint at it to make it go out of focus, or turn the drawing upside down—any of these techniques will help you see the shapes of the drawing rather than just the subject.

In the pastel drawing *Dancer in the Spotlight* (page 66), the basic shape of the figure is a triangle; that shape divides the negative space into three smaller triangles of approximately the same size, arranged evenly around the figure.

Another type of balance exists in *Club Med* (pages 68-69). In that piece the large figure on the left side of the drawing is balanced by the two smaller figures on the right.

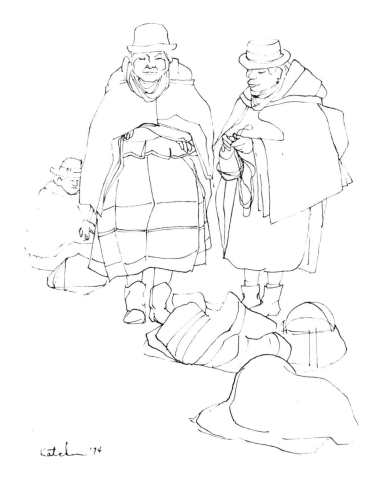

(top right) MARKET PEOPLE, LEIVIA, ink on paper, 12″ × 9″ (30.5 × 22.9 cm).
(bottom right) MARKET PEOPLE, SYLVIA, ink on paper, 12″ × 9″ (30.5 × 22.9 cm).
I drew these people in outdoor markets in Colombia. When I am making candid drawings of people, I either select subjects who are posing well together or I rearrange them in my drawing. When a composition is comprised of several figures, it is helpful to think of the group as one shape. Both of these drawings are of three figures placed closely together. However, it is interesting to see what different shapes the two drawings have because of the arrangements.

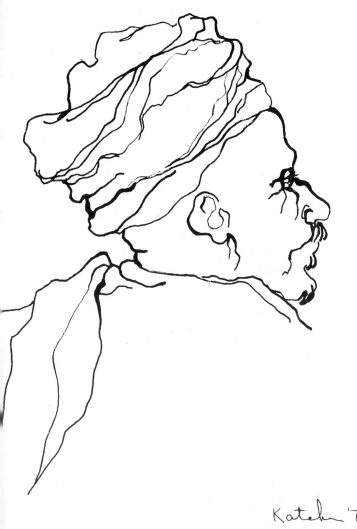

Katch '72

MAN ON A BUS, ETHIOPIA, ink on paper, 9" × 7"
(22.9 × 17.8 cm).
*Generally, when a figure is looking toward one side of a
composition, it is a good idea to leave a lot of space in the
direction the figure is looking toward. That area is typically
more important to the drawing than the area to the back of
the figure's body. In this case, however, I have left almost no
space in front of the figure. The focus of this drawing is the
man himself, not his situation. The lines and shapes in his
headdress and robe are interesting enough to make the
space behind his face more important than the space in
front of him.*

SUBTLETIES OF COMPOSITION

The final elements of composition are rhythm,
movement, and tension. These are the most subtle
considerations in a drawing, and they are the
hardest to achieve. As in music, rhythm in art is
created by repetition of simple elements; in
drawing these elements are line and shape. In *The
Postcard* (page 65) the pattern of the floor is created
with sharp, angular shapes. Notice how these
angles are repeated in the elbows and knees and in
the back of the chair and the table legs. Also the
pattern of squares from the upper right is contin-
ued on the left.

Movement refers to the movement of the
viewer's eye looking at a drawing. A drawing that
has a strong focal point, but no other point of
interest is static. The viewer looks at the focal
point and feels that he has seen everything in the
drawing.

Club Med (pages 68-69) is an example of how an
artist can lead the viewer from the focal point
through the rest of the painting. The female figure
demands your immediate attention because it is
the largest figure and is the mass of darkest value.
However, there are several elements that lead the
eye on to the smaller figures on the right. Most
obvious is the sightline of the largest figure. She is
looking back to the right; the viewer looks to see
what she is seeing. There are repeated diagonal
lines from lower left to upper right, the lines
created by the bodies and shadows. The shoreline
also meanders back to the upper right, and the
blue shape of the ocean is almost like a hand
pointing in the same direction.

But when the viewer's eye reaches the upper
right, it is led in still another direction. Both of the
male figures are looking along the dark horizon line
to the left; so the viewer also looks to the left.

An important concern in composition is how to
keep the balance of the drawing lively and not too
predictable. Look at the drawing *Rose* (page 64).
The basic shape of the figure is a triangle, with the
base sitting right on the bottom of the page—this
is the most stable shape you can draw. But what
keeps the composition from being dull is that the
head is not in the exact center of the triangle. In
addition, the model's left arm is extended and her
head is tilted to the right; this creates a contour
with a strong diagonal thrust from lower right to
upper left. This feeling is reinforced by the
model's glance. Also the model's right arm curves
back in on the bottom, further disrupting that
basic stable triangle.

The ideal composition is stable, but not too
stable, comfortable, but not too comfortable.

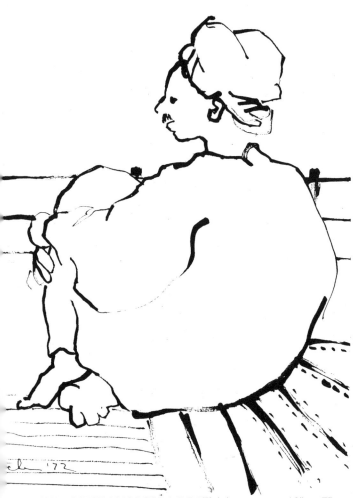

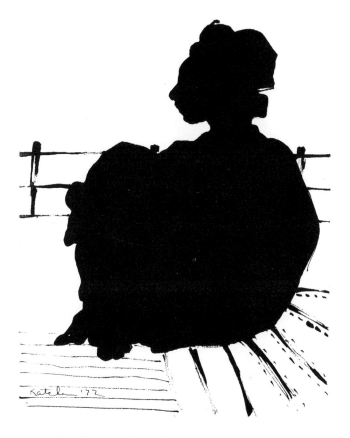

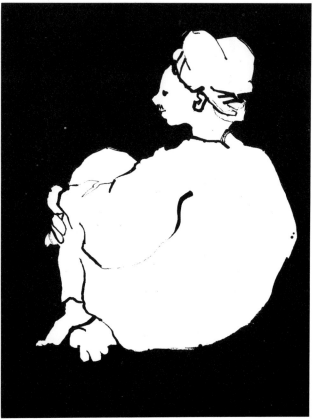

SUDANESE MAN ON A BOAT, ink on paper, 10″ × 7″ (25.4 × 17.9 cm).

This is a pen-and-ink drawing I made of a robed man on a boat on the Nile River. My main concern was to show the rounded, compact shape the man made as he sat curled up in the sun on his rugs. I always think of the figures I draw in terms of the total shape of the body. Notice the simple, basic shape that is created by blacking in the figure so that we see it as a silhouette. No matter how wonderfully intriguing the interior shapes and details of a figure are, the outside contour must also make an interesting shape. The other half of the composition is the negative space. By ignoring the figure and blacking in the background, we are able to visualize the shape of the negative space. Both of these shapes—the figure and the negative space—must be strong in a well-composed drawing.

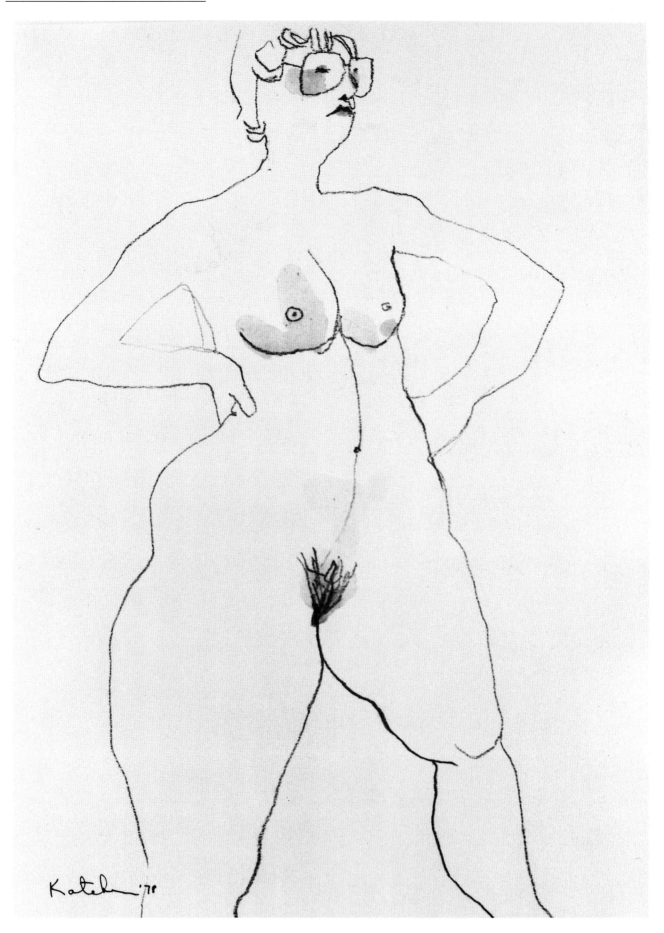

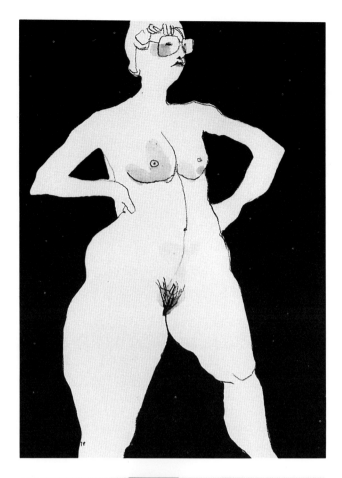

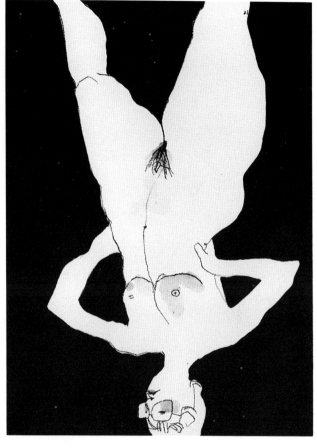

NUDIST, ink and watercolor on paper, 15″ × 11″
(38.1 × 27.9 cm).

*In contrast to the rounded shape of the Sudanese man,
Nudist is an extended figure that fragments the negative
space. Again, notice the shapes that are created by silhouet-
ting the figure and then the negative space. The basic
shapes of a composition should be interesting and balanced
from any direction. Notice that the negative space retains a
striking abstract pattern, even when it is turned upside down
(see above). The abstract shapes in your own work can be
seen by turning the drawings upside down or sideways or by
looking at them in a mirror.*

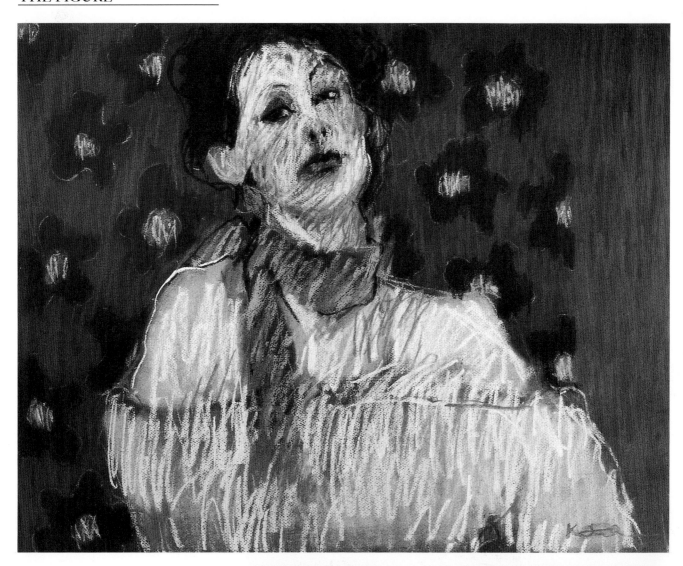

ROSE, pastel on paper, 19″ × 25″ (48.2 × 63.5 cm).

The basic shape of this composition is a triangle, which is a very stable shape. This shape provides an inherent sense of balance, so the challenge in this composition is to create some tension that will make the drawing more interesting. This aesthetic tension is accomplished by making the triangular figure asymmetrical. Notice that the model's left side is a strong diagonal, while the right has a more vertical feeling. Another element that adds tension is the direction of the model's glance, which pushes in the same direction as the diagonal. The arrows indicate the direction of the tension in this piece.

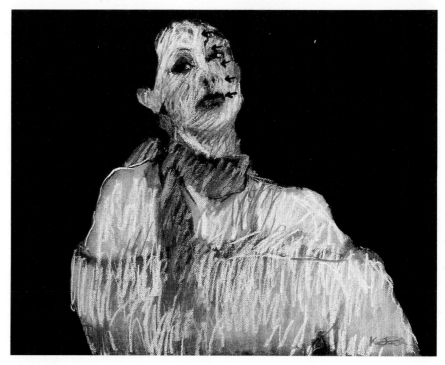

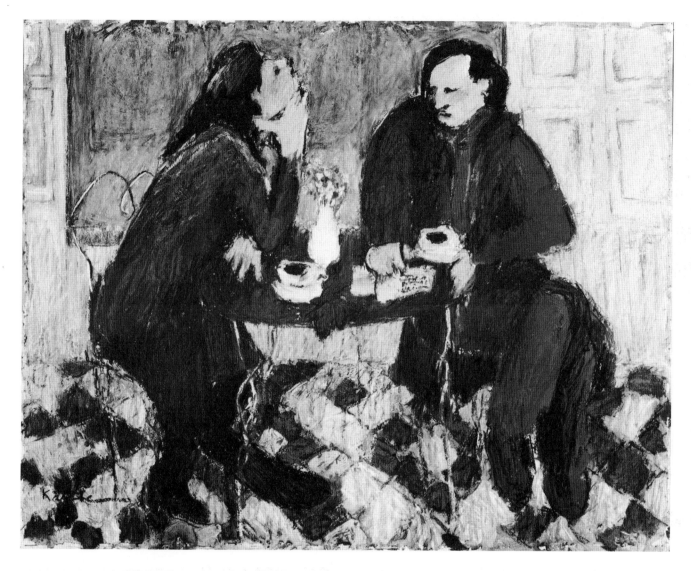

THE POSTCARD, mixed media,
24″ × 30″ (61 × 76.2 cm).
This mixed media drawing is of a quiet, relaxed scene. In order to keep the piece from being so quiet and relaxed that it would be boring, I added some rhythm and movement to the patterns of the figures and background. Notice the angular patterns— the diamonds and triangles—that are repeated in the floor, people, and furniture. This repetition, especially in an irregular pattern, adds a sense of excitement to the drawing.

A more regular repeated pattern occurs in the rectangles at the upper left and right. These also add more visual interest, but with a more stable feeling than the scattered diamonds and triangles.

WINDOW LIGHT, pastel on paper, 39″ × 27½″
(99.1 × 69.9 cm).
*The subject of this drawing is a dancer in the studio. In
portraying the studio I abstracted the environment, repro-
ducing only those elements that add to the total design of
the piece. Even when the background is of primary impor-
tance to the expression or meaning of a drawing, it should
be drawn in such a way that it enhances the composition.
Notice here how the repeated geometric shapes of the
windows and window light create a dramatic contrast with
the organic shape of the figure.*

DANCER IN THE SPOTLIGHT, pastel on paper,
39″ × 27½″ (99.1 × 69.9 cm).
*This drawing is designed in triangles. The figure creates a
large triangle that is almost, but not quite, symmetrical. This
gives the piece balance without being static. The outer
contour of the figure creates three smaller triangular shapes
in the negative space. Notice also the small triangle created
by the dancer's left hand and foot.*

(right) **CLEO IN YELLOW TIGHTS**, pastel on paper,
39″ × 27½″ (99.1 × 69.9 cm).
*Here, the basic shape of the body has such an interesting
design that the negative space can be left very simple. Even
though the figure does not actually touch the outer edges of
the paper, the strong, slashing lines of the dancer's arms
and legs seem to cut through the negative space, making it
appear fragmented rather than one solid shape.*

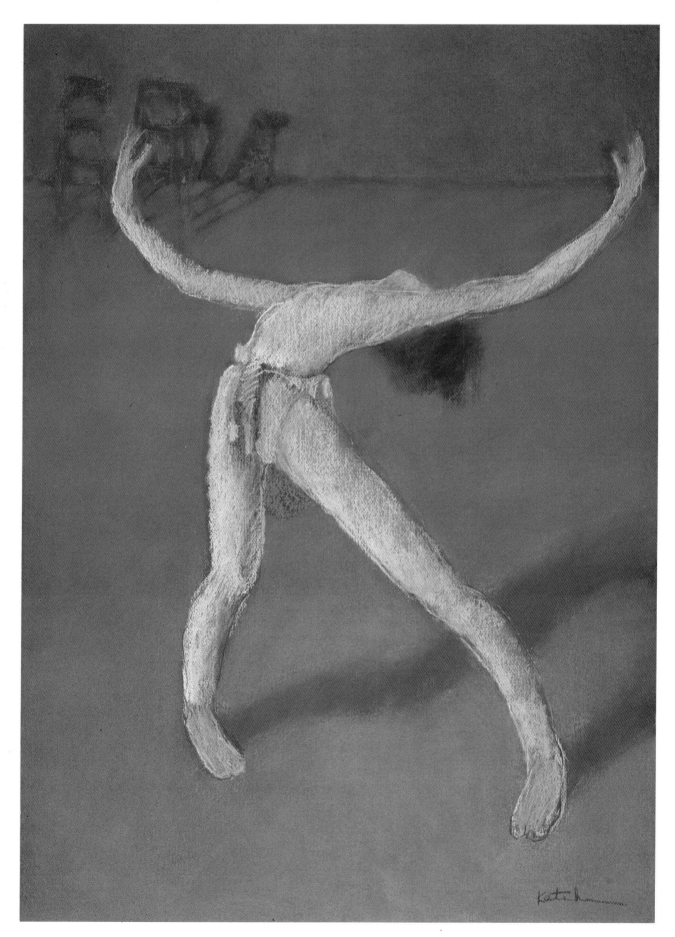

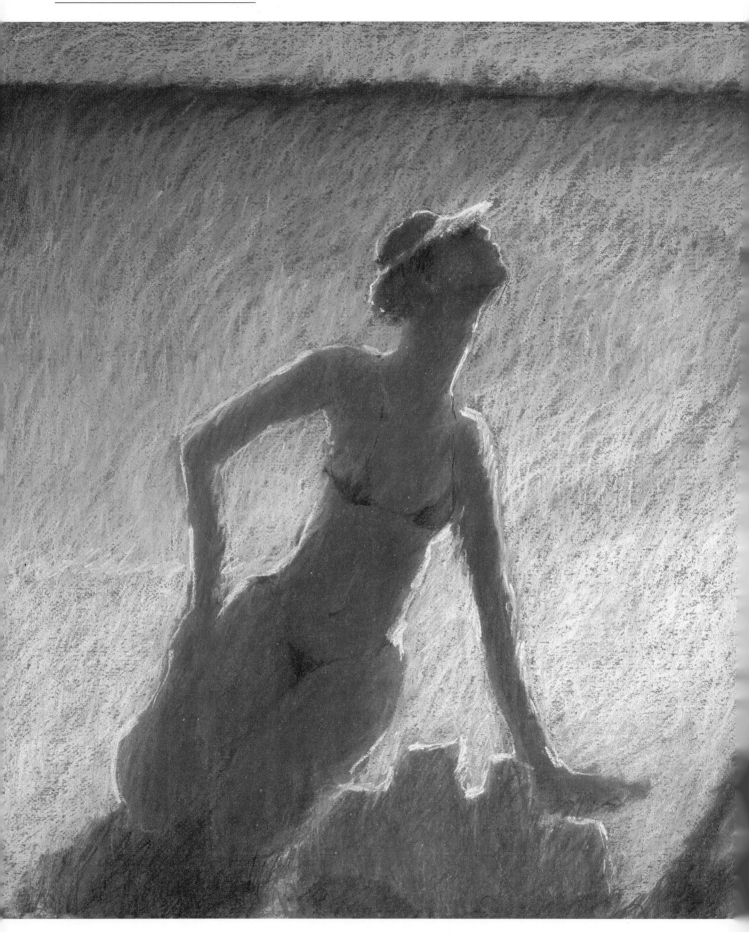

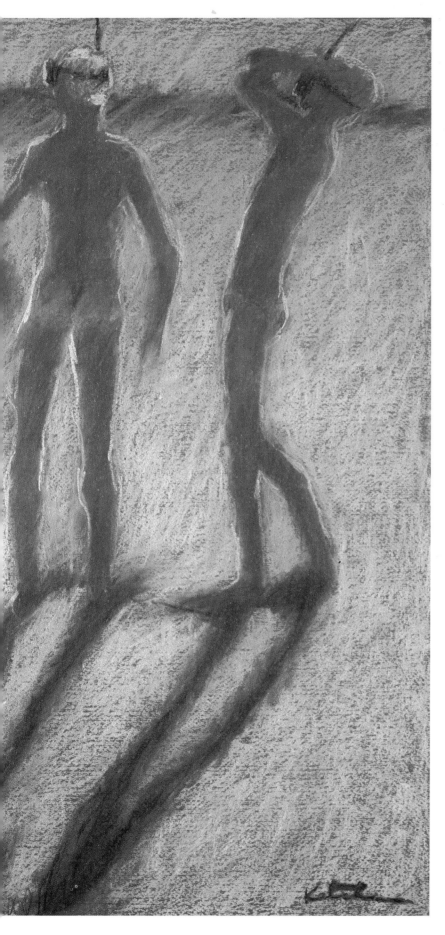

CLUB MED, pastel on paper, 27½" × 39" (69.9 × 99.1 cm).

Notice how the various elements of this drawing make the viewer's eye move through the entire composition. You look first at the female figure because she is the largest figure in the piece. Then the diagonals of her figure and the shadows plus the direction of her attention lead your eye to the two male figures in the upper right. Finally, their direction of sight leads your eye across the strong horizon line to the left.

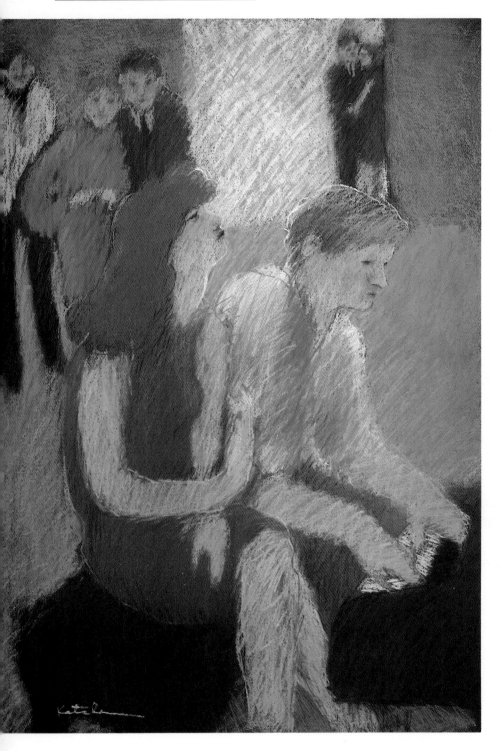

(left) GERSHWIN, pastel on paper, 39″ × 27½″ (99.1 × 69.6 cm).
The seven figures in this drawing form a V-shape against the simple background. The larger figures are more important and their size reflects that, but since all the figures are connected in one basic shape, they are all seen together. I wanted the central figures to be part of the total scene, and this composition accomplishes that idea.

(right) $100 ON THE REDSKINS, pastel on paper, 39″ × 27½″ (99.1 × 69.9 cm).
The scene here portrays four friends watching a Super Bowl game on television. Notice that the four figures are placed so closely together that they become one total shape. Remember that when you are drawing groups of figures, its important to consider the shape of the entire group.

(above) MARY'S BIRTHDAY PARTY, pastel on paper,
27½″ × 39″ (69.9 × 99.1 cm).
*In the chapter on drawing figures in groups (pages 110-
121), we talk about how all the compositional elements
should be seen as basic shapes to be used in a total
pattern. Here we have repeated shapes in the figures, in the
pizzas, and in the glasses of wine. The combination and
spatial relationships of all these forms create the overall
design of the piece.*

(right) HAPPY BIRTHDAY, pastel on paper, 27½″ × 39″
(69.9 × 99.1 cm).
*Here, the three main figures are one large shape separated
by space from all the figures in the background. The large
figures are seen first because of their size and detail. The
background figures are seen later as small, unconnected
vignettes.*

The three background groups repeat the three foreground figures.

Small interior shapes provide interesting patterns inside the major, larger shapes.

The trio of foreground figures is reinforced by the three primary colors of their clothing.

A rhythmic pace is created throughout the drawing by the repetition of identical shapes.

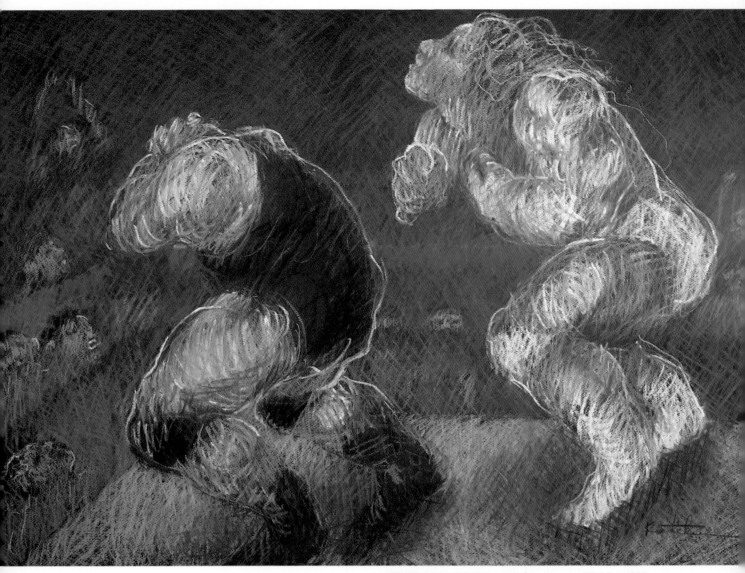

**THE ALL STARS, pastel on paper, 27½″ × 39″
(69.9 × 99.1 cm).**
*This pastel drawing was commissioned by a collector who is
an avid all-star wrestling fan. He wanted a portrayal of the
wrestlers in action. I did numerous pencil studies during an
actual match and completed this pastel in my studio. I
wanted to emphasize the brute strength of these athletic
performers. Notice how the large, rounded shapes of their
figures implies the strength and weight of their bodies.*

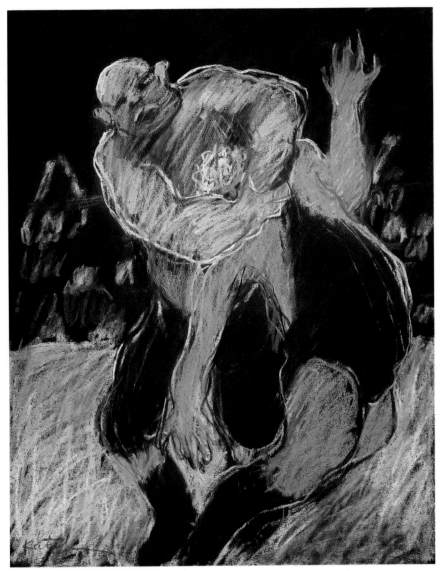

In order to gain a better awareness of how a figure drawing divides into the two basic shapes of figure and negative space, draw three outside contours or silhouettes of your model. In the first drawing, place the figure in your drawing so that there is space all around the body. In no place should the figure touch the edge of the format.

In the second drawing, place the figure so that it touches the edge of the paper in one place.

In the third drawing, make the figure touch the edge of the paper in at least three different spots.

After you have finished the three contour drawings, fill in the background with black or another solid color. Now you will have a graphic demonstration of how the pose and placement of the figure affect the negative space.

BARON VON RASCHKE vs. DR. "D" SCHULTS, pastel on paper, 25″ × 19″ (48.2 × 63.5 cm).
In this drawing of wrestlers I combined the two main figures into one shape. This works for the composition and also adds to the drama of the situation. Notice how the background is divided into a light and a dark area. The light area of the floor contrasts with the dark tights and boots; the dark upper background makes the highlights on the skin more exciting.

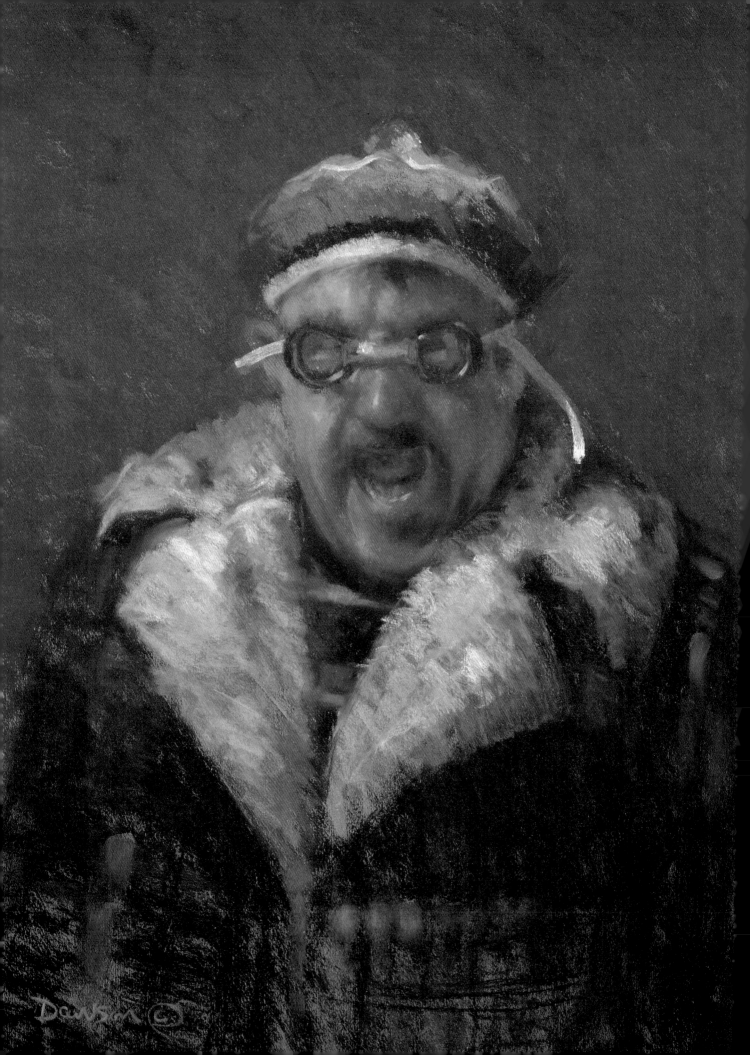

6 MASTERING EXPRESSION

Doug Dawson

"The reason I draw people is to get in touch with emotion—theirs and mine." This is the motivation of Doug Dawson, whose pastel renderings of people always have a tremendous emotional impact. He says, "The easiest vehicle for expressing emotion is the human figure. With a landscape, for instance, it is easy to convey cold, but it is much harder to express loneliness unless there is a figure somewhere in the piece. We are more attuned to seeing emotion in humans than in anything else."

Much of Dawson's work is intuitive. He generally selects models, poses, and colors based on his "gut reactions." He says, however, that there are several elements that contribute to the expressive quality of a drawing or painting and these can be analyzed in an objective way.

EXPRESSING WITH VALUE

The first and often most significant element of expression is value. The initial impact of a piece is created by the overall value. When you stand back from a drawing, notice how dark or light the total work looks. A dark piece, regardless of subject matter, will look heavy, somber, forbidding; a bright piece appears happier, friendlier. Dawson

says that no matter how hard he might try to create a carefree dark drawing, it would probably still look sinister. The pastel *Stephen* (page 83) seems warm and friendly because the overall value is bright. The same pose and facial expression would appear more somber, even ominous, if the background were dark.

Besides overall value of a piece, value can be used for effect in selective areas. In *Priscilla* (page 80) the dark shadow across her face makes her look pensive, even though the colors of the piece are warm and happy.

The quality of the light also affects expression. A bright light source will create strong, definite highlights and shadows. This will express a more dramatic feeling than a soft, overall light that lets the bright and dark areas blend smoothly together. A soft light expresses a soft, feminine feeling; a harsher light is more aggressive.

GESTURE OF THE FIGURE

Dawson says, "I think about gesture early in a painting, long before I think about facial expression. The total gesture, the way the whole body is being held is very revealing of who the model is. I

THE FURY OF KENNY, pastel on primed Masonite, 26″ × 20″ (66 × 50.8 cm).
Dawson sometimes selects a model just because the person makes him laugh. Kenny was such a model. The humor in the piece results from the comical costume set against a dramatic facial expression. The piece is humorous without being slapstick funny because Dawson has drawn the figure and his clothing in a very realistic way, avoiding exaggeration.

am already working out the body language when I am blocking in the first values."

A drawing that shows the importance of gesture or body language for expression is *Bonnie Nude* (page 81). Generally, a nude study of an attractive woman conveys a soft, warm feeling, but here Dawson has created a much bolder, more aggressive statement. Notice the tension created by the sharp angles of the arm and back and the taut placement of the head and neck; these elements express a power and wariness uncommon to nudes.

COLOR

There have been many studies of the psychological effects of various colors. The studies "prove" that yellow makes people feel happy, blue makes them calm, etc. Whether or not this is valid for psychologists, it is much too simplistic for artists. Some yellows are warm, happy colors, but some yellows are actually cool. Some blues are peaceful, others are electric. Rather than being concerned with specific colors, it is more effective to be aware of color temperatures and brightness. Another important consideration is how colors are placed next to one another within a painting.

Dawson thinks about color when he first sets the pose, noticing how the colors of skin, hair, costume, background, and props work together. Then he chooses a limited palette of three or four pastels to begin the work. After that his use of color is emotional rather than intellectual.

He says, "Once I am painting with the pastels, my concern for color is just does it work? A color that works is harmonious with the rest of the painting. It either enhances or detracts from my original feeling."

FACE AND HANDS

The face and hands are the two most expressive parts of the body. Dawson is especially conscious of the eyes and mouth because they give the biggest clues as to what the model is feeling. Much of the intensity of *Bonnie Nude* (page 81) is created by the confrontive eye contact between the subject and the viewer. In *Lady in Morning* (page 84), a languid mood is established by the relaxed mouth and eyelids.

The position and tension of the hands can reinforce, modify, or totally contradict the emotion projected by the face. The artist must be aware of what both the face and the hands are expressing. Most artists who draw people devote time and energy to learning how to render the face. Dawson says to express strong emotion, you must also learn to render hands.

PROPS, COSTUME AND BACKGROUND

Props and costume should be selected because they enhance the desired effect of the painting or drawing. In *Nadine at Tea* (page 85), the teapot and cup are used because they lend elegance and dignity to the piece. The props are consistent with the mood already established by the upright posture, the self-assured facial expression, and the graceful lines of the furniture.

Dawson lists four possible kinds of background:
1. Plain, solid color, such as a toned, unadorned wall.
2. Realistic environment, drawn realistically.
3. Abstracted environment—the actual shapes and colors that are surrounding the model, but drawn in a looser, more abstract style.
4. Invented abstraction—arbitrary shapes and colors used to make the composition more interesting.

Dawson says that the type of background used should contribute to the total expression. Using a particular background just because it is easy or available is senseless unless it adds to the feeling of the piece. Notice how the bedroom interior is integral to the gentle mood of *Diane's Pink Gown* (page 80).

TECHNICAL CONSIDERATIONS

The composition can do much to establish mood and thus expression. The relative sizes of figure and ground and the total size of the format both affect the expression. If, for instance, a figure is being drawn very small, the artist will not be able to convey facial expression and will be forced to rely more on body language.

Media and style should also be chosen to enhance the desired expression of a piece. Notice the loose, impressionistic strokes in *Eight P.M. Bus* (page 79). The figure and the background are drawn with soft, indefinite strokes that blend together, giving the feeling that the figure is part of or subject to the wet, evening environment.

COMBINING ELEMENTS

The most emotionally evocative works are created with combinations of expressive elements: value and gesture and background all working together to establish the exact feeling the artist wants to convey. This harmony requires great diligence and sensitivity of the artist, where he or she must not ignore any element of the composition or leave any element to chance. The artist must decide at the beginning what is the desired emotional result and constantly work toward that end.

THE 8 P.M. BUS, pastel on primed Masonite, 12″ × 10″ (30.5 × 25.4 cm).
Mood is established as much by the background as by the figure. Dawson is concerned here with making the figure an integral part of the environment. The figure is made important by being large and dark and in the foreground of the painting; however, Dawson has minimized the attention to the figure by drawing her with loose, impressionistic strokes that blend her into the total scene.

DETAIL
The close-up reveals soft blurring of ochres, pale greens, and browns. This blending of one color into another states the mood and atmosphere of the drawing, which evokes the humid, cold air and warm glow of lights often seen on winter evenings in the city.

79

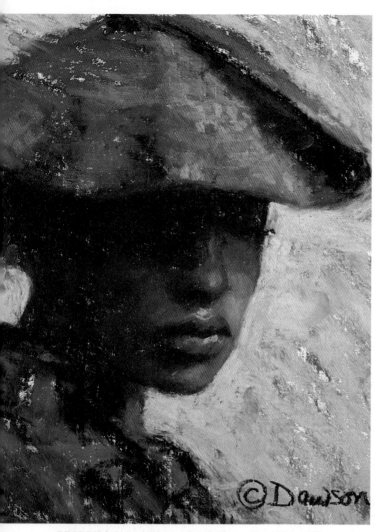

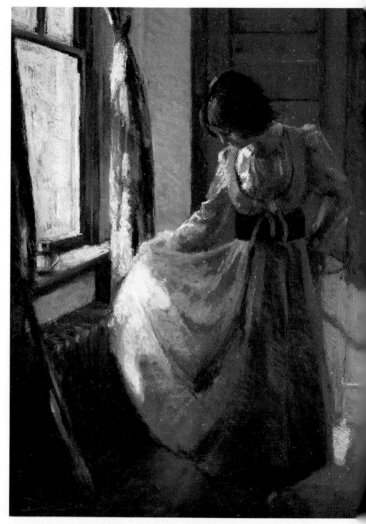

PRISCILLA, pastel on primed Masonite, 12″ × 10″
(30.5 × 25.4 cm).
*This painting shows how value can be a strong way of
expressing emotion. The heavy shadow across the face
gives Priscilla a somber look. This is made greater by the
juxtaposition of the bright hat and background. The serious
expression of the mouth intensifies the basic feeling.*

DIANE'S PINK GOWN, pastel on primed Masonite,
18½″ × 15″ (46.9 × 38.1 cm).
*This is an atmospheric pastel drawing where Dawson was
preoccupied with the feeling of the light coming into the
room. The model was responding to the pleasure of examin-
ing her pink dress in the sunlight. The warm, joyful feeling is
created by the expression of the figure and by the whole
room. One of the reasons the piece works is because of
Dawson's careful use of value; there is no true white, but the
other values are dark enough to make the lights look like
sunshine.*

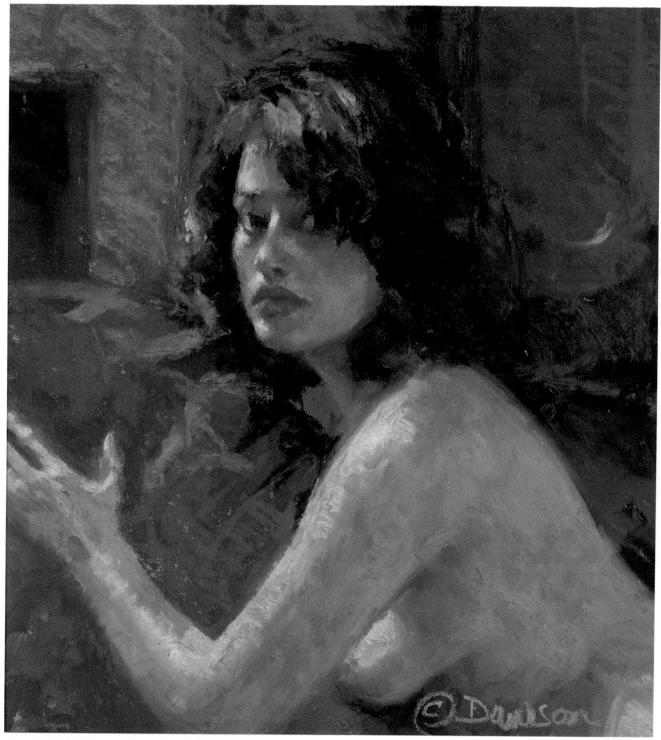

BONNIE NUDE, pastel on primed Masonite, 14″ × 13″
(35.6 × 33 cm).
*Dawson describes this model as having a realistic rather
than idealistic beauty. This is a tense, aggressive nude,
unlike the gentle, submissive nudes that are more commonly
painted by most artists. Notice how the tension is conveyed
by the straight, angular placement of her arm and hand. The
confrontive position of her head and eyes also reveals the
determination of the model's personality.*

PORTRAIT OF JEROME, pastel on primed Masonite,
33″ × 37″ (83.8 × 94 cm).
Dawson says that he is getting more manipulative with his subjects. Originally he planned to use Jerome as the main figure in a drawing with a state fair background. At the time, he was also working on a cityscape of New York. However, Jerome at the state fair seemed too empty to Dawson, so he threw Jerome into the drawing with the backdrop of New York City—and it worked. Actually, Jerome has never been to New York, but to Dawson he looked like the type of character he would expect to see there.

STEPHEN, pastel on primed
Masonite, 30½″ × 24″
(77.5 × 61 cm).
The solid, frontal pose is an aggressive stance. By using that pose here Dawson could have created an ominous, hostile mood. However, he added a bright background and the whimsical sunglasses, and thus made the subject appear to be a more friendly, approachable person.

The pale background brings the figure forward, creating a vignetted effect.

The greater detail evident in the face and hands makes these areas the focal points of the drawing.

The contrast of the pale background with the brilliant color of the red sweater emphasizes the areas of negative space.

The muted blue color of the jeans allows the figure to merge with the background in those areas that the artist has intended to de-emphasize.

83

(above) LADY IN MORNING, pastel on primed Masonite,
16″ × 20″ (40.6 × 50.8 cm).
Dawson chose this model because of her sultry quality,
which is conveyed here by the reclining pose and the
languid expression of the eyes and mouth. He has drawn the
model's eyes half-covered by the upper lids, which helps to
convey her sleepy, provocative attitude. The bright light
behind the model and on the right side of her face evokes
the feeling of morning.

(right) NADINE AT TEA, pastel on paper,
32″ × 29″ (81.3 × 73.7 cm).
Dawson enjoys "play acting" with his models, improvising
costumes and props to develop a dramatic situation. That is
how this theatrical piece evolved.
 Here, Nadine is posed in an erect posture that expresses
the proud, elegant side of her personality. The hat and dress
make the scene appear very feminine. The graceful lines of
the furniture and teapot also add to the elegance of the
scene. Dawson analyzes each element of a drawing to
decide if it will enhance or detract from the total feeling or
mood he is trying to express.

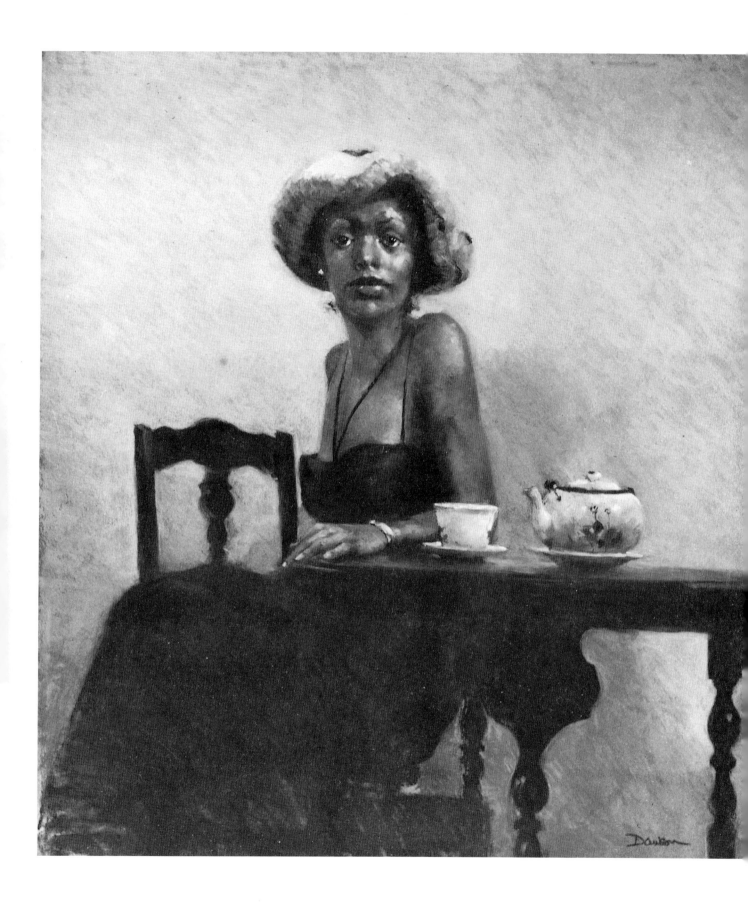

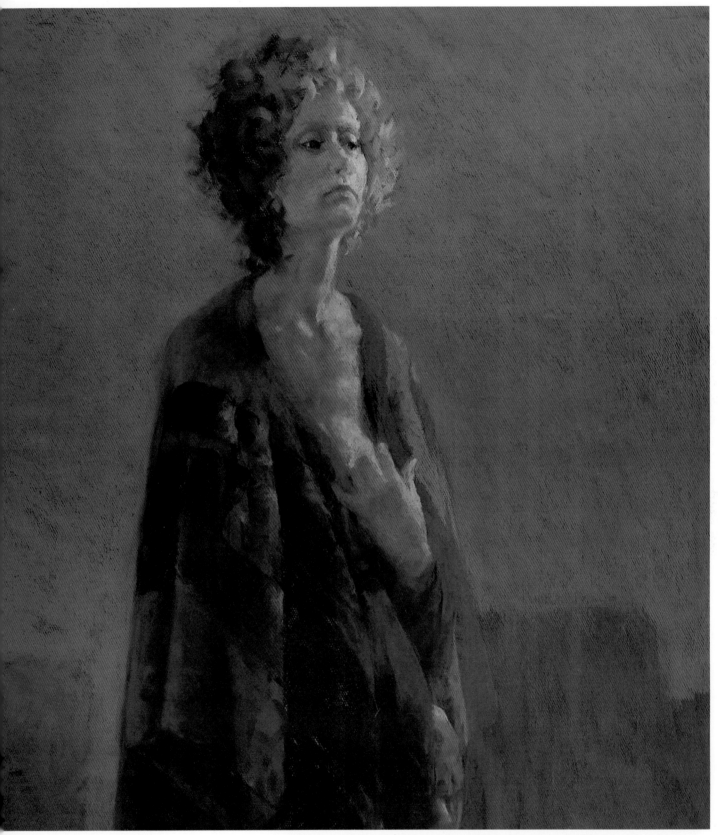

THE PLAINTIFF, pastel on primed Masonite, 33″ × 26″ (83.8 × 66 cm).
Here Dawson was caught up in the drama of the pose, which looked to him like someone pleading her case before a judge. In many of his pastels, Dawson creates drama with shadows; in this he creates drama with highlights. Notice the light on the face that emphasizes the model's long, thin neck and gaunt chest.

THE DESIGNER, pastel on
paper, 26 " × 22" (66 × 55.9 cm).

Stage 1
*Dawson begins by blocking in the
dominant shape of the composition,
uniting all the flesh areas in one
shape. He uses a light orange color
for the flesh. He centers the main
shape because this is a direct, con-
frontational piece.*

Stage 2
*With raw umber Dawson blocks in the
background and the front of the figure.
He is beginning to establish the mood
of the piece with the dark values, by
having the figure looking out from the
darkness.*
*He indicates where the facial fea-
tures will be. With alizarin crimson he
blocks in the shadowed side of the
face and hands. Dawson develops a
painting by first establishing the larg-
est shapes, then gradually subdivid-
ing those into smaller and smaller
shapes.*

87

Stage 3
With the same colors Dawson further defines his shapes. He says, "The placement of the pupils is very important in establishing that the model is looking directly at me. At this stage I am establishing the confrontation with the eyes. This helps me to establish the total feeling of the piece early on, making it easier to sustain that feeling throughout the process."

Stage 4
Here, Dawson blocks in the crimson dress; the dramatic color helps to reinforce the sense of confrontation. He blocks in the basic color of the fur coat and starts to use some lighter values in the face and hands to make them more three-dimensional.

(right) Stage 5
At this stage, Dawson introduces some cool color into the fur coat. This changes our perception of how the other colors look. Before, the whole painting was warm; the blue gives it balance.

Dawson uses the same cool color from the coat in and around the eyes. Whenever Dawson introduces a new color, he tries to use it in more than one part of the painting. This helps him maintain color harmony.

Stage 6
Developing the facial features and the form of the hands has been a gradual process. In this last step, Dawson completes that refining process.
The final feeling of this drawing is one of confrontation: eyes straightforward and chin up. The woman looks confident, proud, but not hostile. Note that hands soften the aggressiveness of the pose; they are turned back to the model in a protective position.

BONNIE IN GREEN, pastel on primed Masonite, 15½" × 14" (39.4 × 35.6 cm).

Stage 1
Dawson first blocks in the basic shapes. He begins to create tension in the piece by turning the head to look over the right shoulder. He lays the foundation for dramatic lighting by juxtaposing the light value of the face against a dark value for the background.

He begins by picking out three basic colors of pastel—an orange for the light value, violet for the medium value, and gray for the dark value. He uses the orange and violet here and will introduce the dark gray in Stage 2.

Stage 2
Dawson fills in more of the dark background and draws in simple lines to show where the features will go. The vertical line through the face establishes a tilt to the head. The gesture of the spine and the angle of the head convey much of the total expression of a figure.

91

Stage 3

Dawson uses carmine red to divide the large shape of the face into smaller areas of light and shadow. The red is a passionate color that adds drama and vitality to the work. He also uses some of the new color in the blouse and background; whenever he uses a new color in one area of the painting, he tries to use it in other areas as well. Repeating his colors in this way helps maintain color harmony throughout the painting.

Stage 4

Blocking in the cheekbone, Dawson begins to establish a three-dimensional quality to the head. He then starts to define the shadowed areas of the facial features. As in all his work, Dawson works from the largest shapes to the smaller shapes. This process helps him control the composition of the piece. At this stage he works with the features as abstract shapes. He will not focus on the specific details until later.

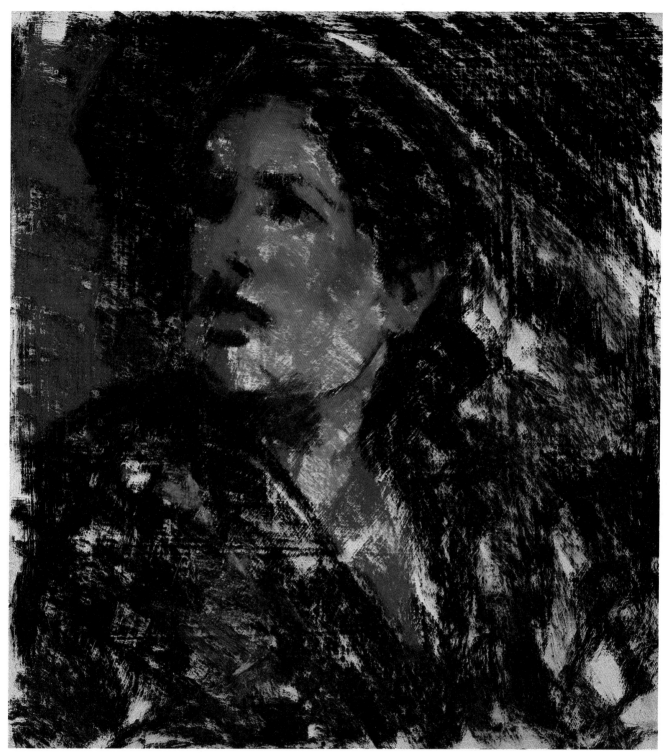

Stage 5
At this stage, Dawson continues to fill in the dark areas of the hair, background, and blouse, using cool colors to contrast with the warmth of the flesh tones.

Notice the shape of the flesh area down the front of the blouse. This shape forms a dramatic sharp angle with the centerline of the face, which increases the general tension of the pose. Dawson establishes the shapes of the eye and eyebrow and begins to create the serious, intense expression with these basic shapes.

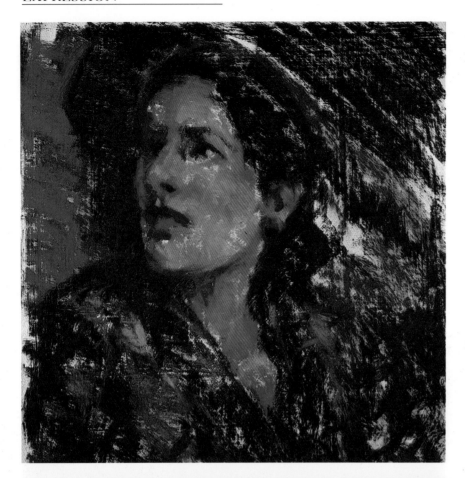

Stage 6
Dawson draws in the light area of the eye, establishing the direction of the model's glance. He also develops the full, sensual shapes of the mouth. By defining the bottom of the nose and chin, he firmly establishes the upward tilt of the head.

He adds pink to tone these areas where the skin is a warmer color—the nose, chin, cheek, ear, and collarbone. He explains that flesh often appears warmer where the bone pushes closer to the surface.

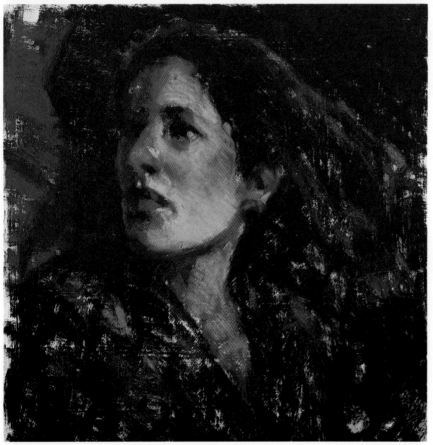

Stage 7
Dawson defines the expressive area around the mouth. He further refines the other features of the face, especially the lip, jawline, and eye areas.

Here, Dawson begins to use more lighter values. Because lighter values appear closer to the viewer's eye, they help develop the three-dimensional quality of the piece. He hesitates to use light colors early in a painting. He has found that if he makes a mistake and has to cover the light values, it tends to muddy all the color.

(right) Stage 8
With color and stroke, Dawson defines more of the folds and textures of the fabric in the blouse and background. He wants these areas to be solid even though they are not as specific as the face.

In this final step Dawson adds the last dramatic highlights to the face, hair, and blouse. This is a simple head study, but Dawson has given it emotional impact with dramatic lighting, tension in the pose, and an intense facial expression.

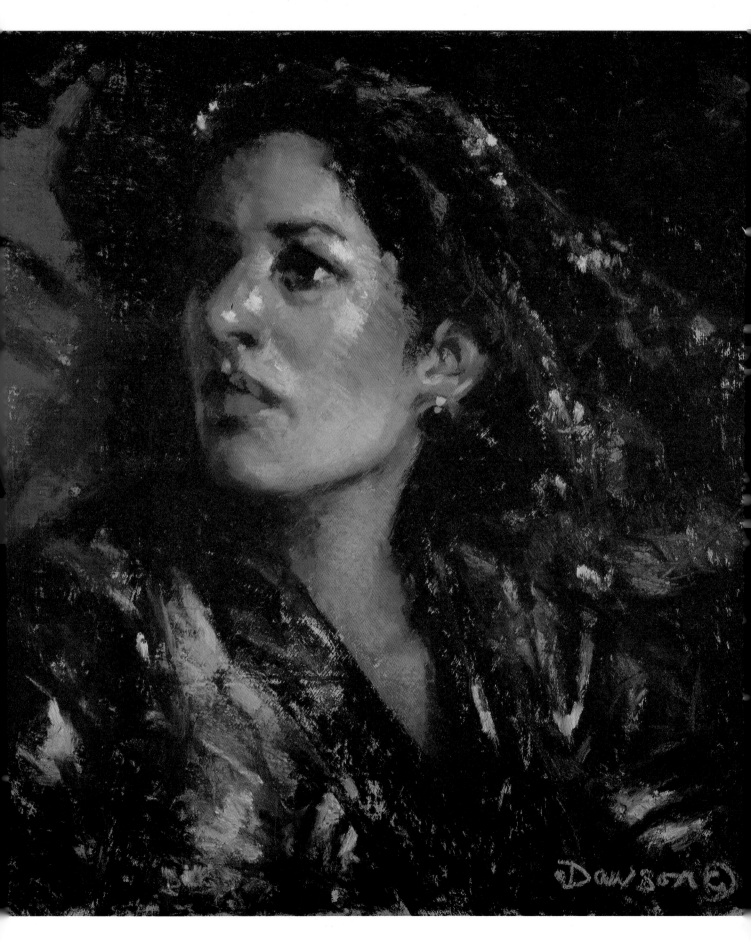

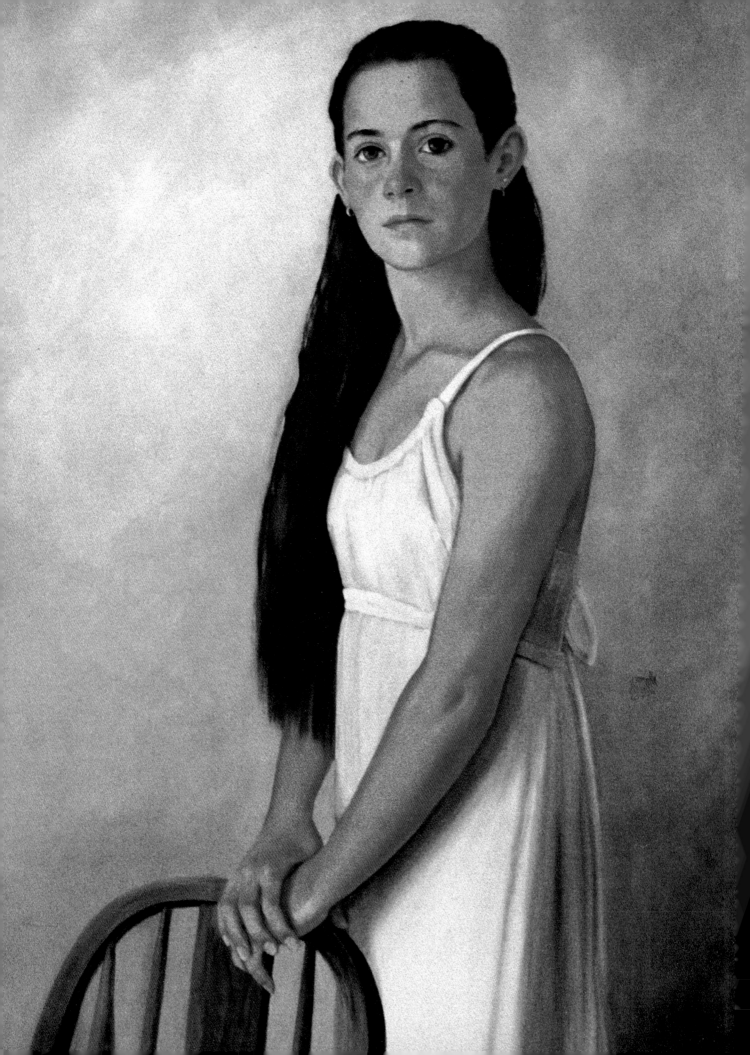

7 CAPTURING A LIKENESS

Claire Evans

Claire Evans, an artist known for her ability to paint successful portraits, maintains that achieving a likeness is never a simple matter of reproducing facial features. Besides facial characteristics, Evans says, pose, gesture, personality, and costume all contribute to the portrayal of who that person is. She believes that a good likeness is the result of capturing the expression of the whole person, not just a physical appearance.

Evans explains, "If you know a person well, you can recognize that person walking down the street two blocks away, just by his gestures. No matter how well you get the features, if you don't have the right gesture, you won't have the person."

In addition, you must achieve a likeness of personality as well as features or you will probably end up with a plastic image. Evans says that for her the fun part of portraiture is learning to "read" people. She looks for "the odd wrinkle of character" and says that even little babies are different from each other.

Evans usually spends the first twenty minutes with the subject just talking. She says, "We talk about what kind of image they want to project, where they will hang the painting, what they would like to wear. Some people want to be painted the way they aren't. I painted a chairman of the board as if he were the chairman of IBM. He was actually chairman of the board of a company with two people in it!

"People have their own way of holding their hands, hunching their shoulders, tilting their head. They assume unnatural positions when they are nervous or self-conscious. I visit with them so they'll relax. While we are talking and they feel at ease, I look for the gesture and attitudes that are natural to them. Then when we set a pose, I use those comfortable positions."

CHOOSING THE POSE

There are many considerations in choosing the pose for a portrait. Besides looking for a pose that uses the natural gestures of a subject, Evans also picks a pose that conveys something of the personality. She says, "When I draw strong, assertive people, I might put them smack in the middle. Once I painted an extremely shy girl; I placed her in the corner of the composition."

Another consideration is whether the pose

PORTRAIT OF VALERIE, oil on canvas, 44″ × 28″ (111.7 × 71.1 cm).
This is a portrait of a young dancer who the artist says is a very determined young lady. Evans placed her right in the middle of the canvas, looking directly at the viewer to express Valerie's assertiveness. The position of the head and the serious expression also give a sense of the young woman's personality. Evans believes that in order to achieve a strong likeness, you must capture the subject's personality as well as physical features.

makes the subject more or less attractive. Evans points out that nobody is symmetrical; usually there is a strong side and a weak side. She rarely paints people straight on, so she must decide which side to emphasize. She usually looks for the side with the stronger muscles.

Evans prefers drawing and painting directly from the model, but she says that nobody seems to have the time to sit and pose anymore. She recalls how she spent an entire day with the lieutenant governor of Colorado trying to get him to pose. She followed him all over the state house and never even found five minutes when she could get him to sit still for her.

Consequently, she must often work from photographs rather than a live model. When that is the case, she devotes the first session to photography. During the second session, she shows the photos to the subject and lets the subject pick out the pose and expression that are more pleasing to him or her.

LEARNING TO DRAW "NORM"

Before you can draw a portrait of a specific person, Evans says you must be able to draw "Norm," that is, you must know the characteristics and proportions of a normal figure.

"Study anatomy books," she says. "If you can't draw the norm, you can't draw how this person varies from the norm. A student once said to me, I don't want to learn figure drawing, I want to learn portraiture. Even literally copying a photograph will look like a flat copy unless you understand what is going on in the figure.

"Then after you know the figure, you have to leave that knowledge behind you. In portraiture especially what you see is more important than what you know. If you want a likeness, you have to draw what is atypical about that person. Then you avoid getting a stereotype."

BEGINNING TO DRAW

Before you draw the features, you must have the mass that is the head shaped correctly, remembering that the head is muscle and bone. Ask: What is this person's skull shaped like? Is there a tilt to the head; how does that fit onto the slope of the neck? Is the forehead receding or protruding? What is the jawline shaped like? Evans points out that the jawline has a lot to do with the way you set your mouth and the way you go about life.

After Evans has drawn the shape of the head, she draws or imagines horizontal and vertical guidelines through the face. She draws a line to indicate the position of the eyes and compares that

to the perfect horizontal. In most faces, she says, the eyes fall midway between the top and the bottom of the head; however, Evans always looks at the specific head before her and marks where these specific eyes are. Then she draws a vertical line to indicate the angle of the nose. She checks to see how that angle compares to the perfect vertical guideline.

Next, she analyzes the nature of the specific features. Which eye is dominant? There is no such thing as a person whose eyes match, Evans maintains. How is this mouth different from the norm? Most people's lower lip is more developed and fuller than the upper—is that true here?

FITTING THE HEAD ON THE BODY

Evans says that the tilt of the head fits into the neck muscles and that angle affects the attitude of shoulders. Relationships such as this are found all over the body; it all has to fit together right in order for the person to emerge on the paper.

In drawing the body Evans tries to be very objective, using plumblines, angles, negative space, and the total shape of the figure to achieve an accurate rendering. She drops a plumbline from the corner of the eye or the tip of the nose, then looks to see where it would fall through the rest of the figure. Would that straight vertical line hit the ankle, the hip? She is constantly comparing and measuring to find the exact angles and proportions of the particular body and pose.

Evans relates, "I've seen some supposedly reputable portrait painters who put the same hands on everybody. You can't paint generic hands. Look at the pose of these hands, the shape of these fingers, the shape of these nails. And it's the same with every part of the body. Every feature must be that specific feature of that specific body."

STUDY OF VALERIE, charcoal and pencil on paper, 18″ × 12″ (45.7 × 30.5 cm).
This is a preliminary sketch for the formal portrait (see page 96). Here Evans developed the basic gesture, value, and composition. She established the tilt of the head, the posture, and the placement of the hands in this early drawing. Notice the development of value in the body, which follows the same 1–2 approach that Bob Thomas described in chapter 2 (pages 26-39). The left side is the bright side and the right side is the shadowed side, with little variation in between.

Evans believes that every portrait, no matter what medium it will be finished in, begins with a drawing. It is in the drawing where she works out all the most important aspects of design.

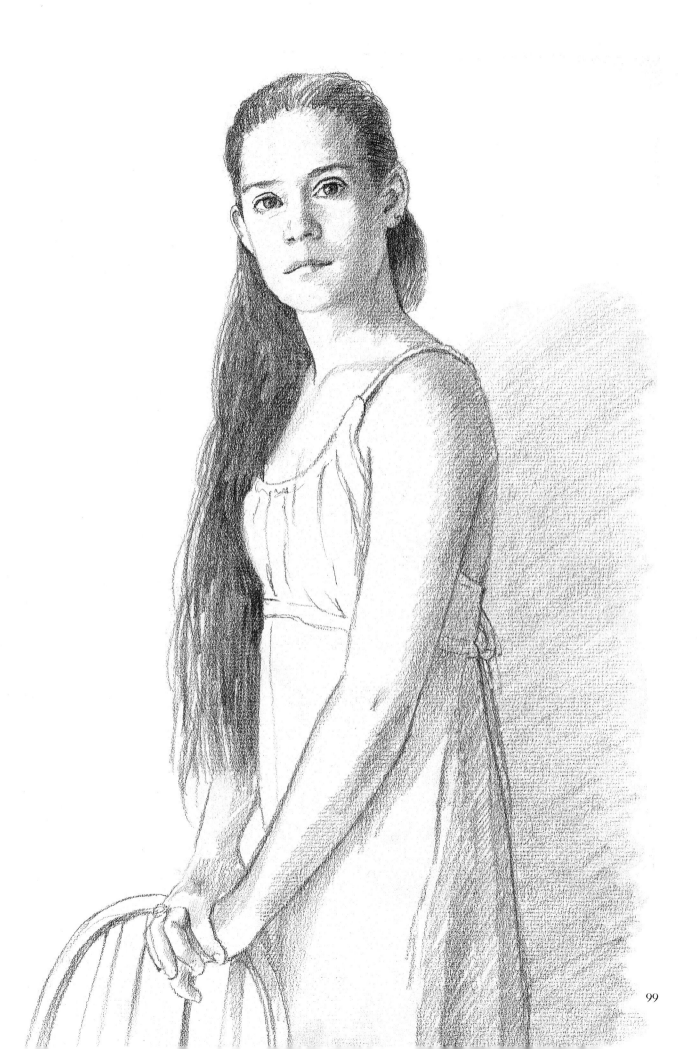

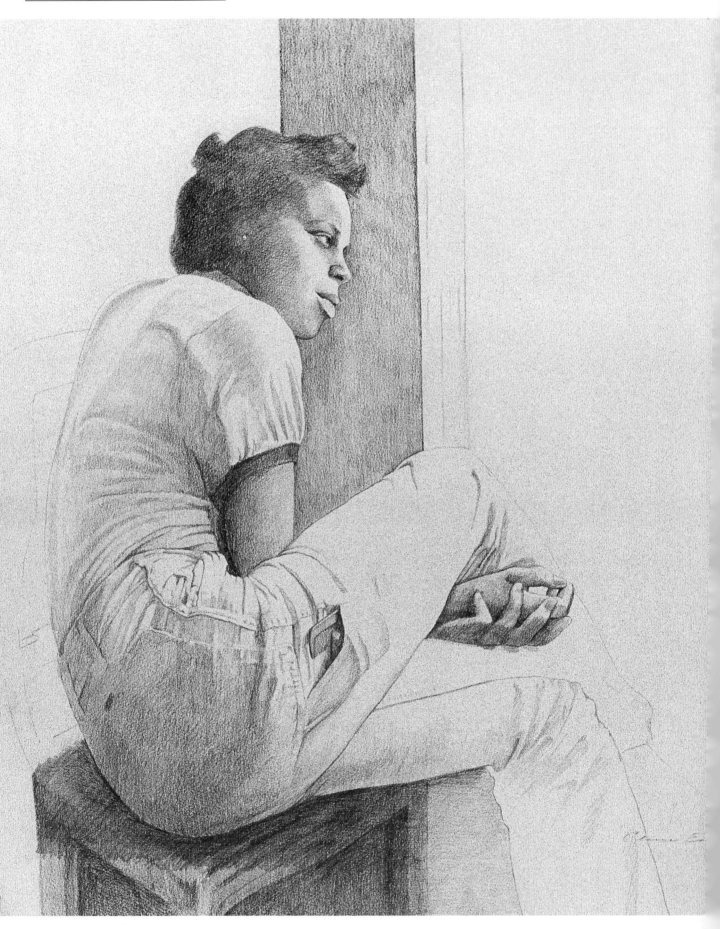

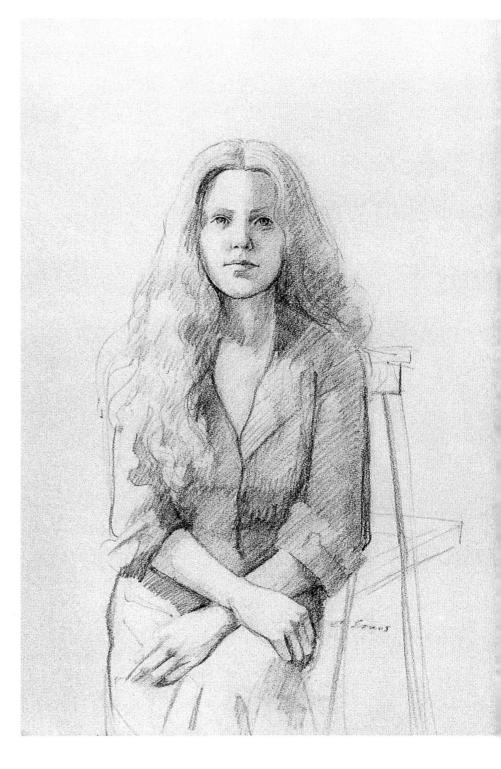

(left) CARLIE, charcoal and pencil
on paper, 26″ × 24″
(66 × 61 cm).
*This is a drawing Evans did for her
own personal enjoyment rather than a
portrait commission. She selected a
pose natural to the model and did a
tight pencil rendering just because
she enjoys capturing details. Notice
the wonderful, rounded shape of the
back and hip. This large, simple
shape contrasts strongly with the com-
plex forms of the model's hands. Even
though the elbows are not visible in
the drawing, Evan's mastery of anat-
omy makes the viewer believe that
what is not seen of the body is just as
real as what is drawn.*

(right) SUSAN, charcoal and pencil
on paper, 24″ × 16″
(61 × 40.6 cm).
*Here Evans uses a simple, classical
pose. Susan is one of her favorite
models because she is a very relaxed
person. She naturally assumes grace-
ful poses and is able to hold them for
a long time. In this drawing, as in
many of her works, Evans has ren-
dered some parts of the figure very
tightly and left other areas as mere
suggestions. When you finish a draw-
ing in this way, leaving areas of the
drawing loosely sketched, you must
be sure to draw the most important
parts of the figure in the tighter style.
Because people are attracted by spe-
cific details and the richer values, a
viewer's eye will go immediately to the
highly rendered areas.*

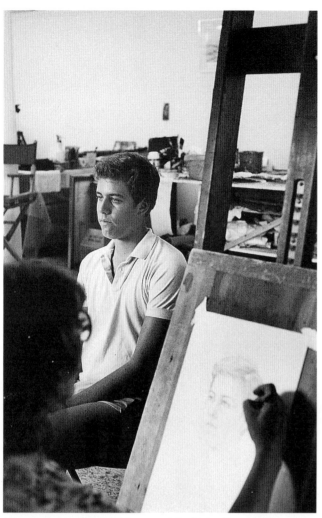

Model Paul posing for his portrait in Claire Evans's studio.

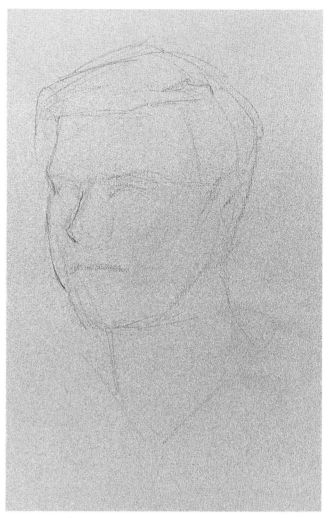

PORTRAIT OF PAUL, charcoal and pencil on paper,
20″ × 16″ (50.8 × 40.6 cm).

Stage 1
First Evans draws the overall shape of the head, concerning herself with the tilt of the head on the neck. She draws a line through the eyes. Paul has a longer chin than most people do; so there is more space below the chin than above. She locates the tip of the nose and the mouth.

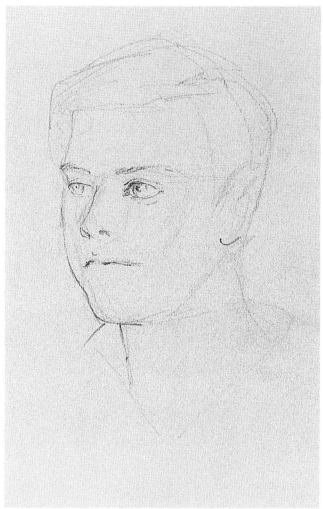

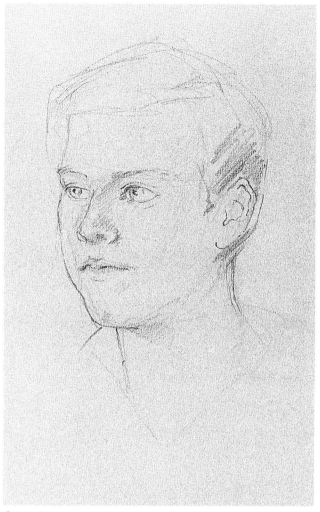

Stage 2

Evans defines the shape of the eyes by studying the abstract curves; people have different shaped eyes, she says, and quite often the eyes don't match each other.

Evans places the earlobe and compares its placement to the nostrils. She brings the chin down more and makes the outline of the cheek more exact. She gives more definition to the mouth by establishing the line that separates the lips.

Stage 3

Here, Evans becomes involved with the development of the mouth. She says that when the likeness is off, half the time it is because something is wrong with the mouth. She notes the exact shape of the middle line of Paul's mouth and checks whether the lower or upper lip is dominant. In Paul's case, the vertical groove above the upper lip, or Cupid's bow, is a predominant feature that should be emphasized.

Evans insists that generic ears won't do; you have to get each person's particular ears. She notes the shape of the outer shell. Paul's ear is pointed on top and has a long lobe.

She begins to shade the side of the nose, the hair, and the chin.

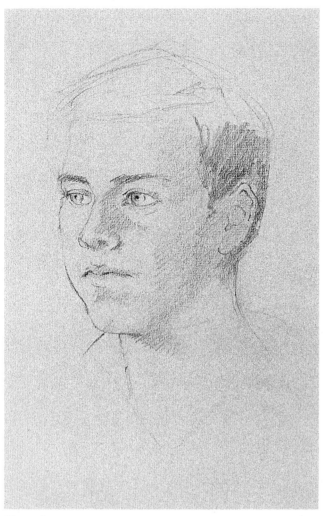

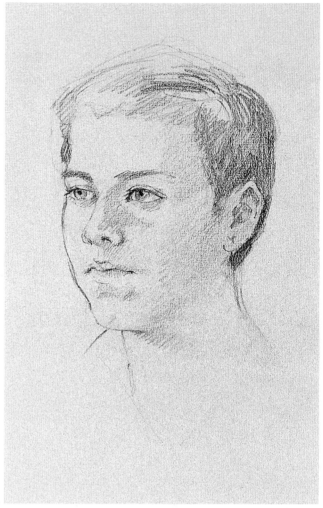

Stage 4
*Evans corrects the setting of the right eye and makes sure
that the pupils match. She shades around the cheeks, going
under the mouth to show the fullness of Paul's cheeks.*

Stage 5
*Evans enlarges the pupils and starts to draw in Paul's heavy
lashes. She indicates the direction of his hair growth. She
puts more shading in the face, looking for the values on this
particular face in this particular light.*

(right) Stage 6
*Evans cleans up the guidelines and the smudges on the
shaded side of the face. She adds detail to the hair and
shades the upper lip so that it will curve inward. The portrait
is completed with a simple contour drawing of the collar.*

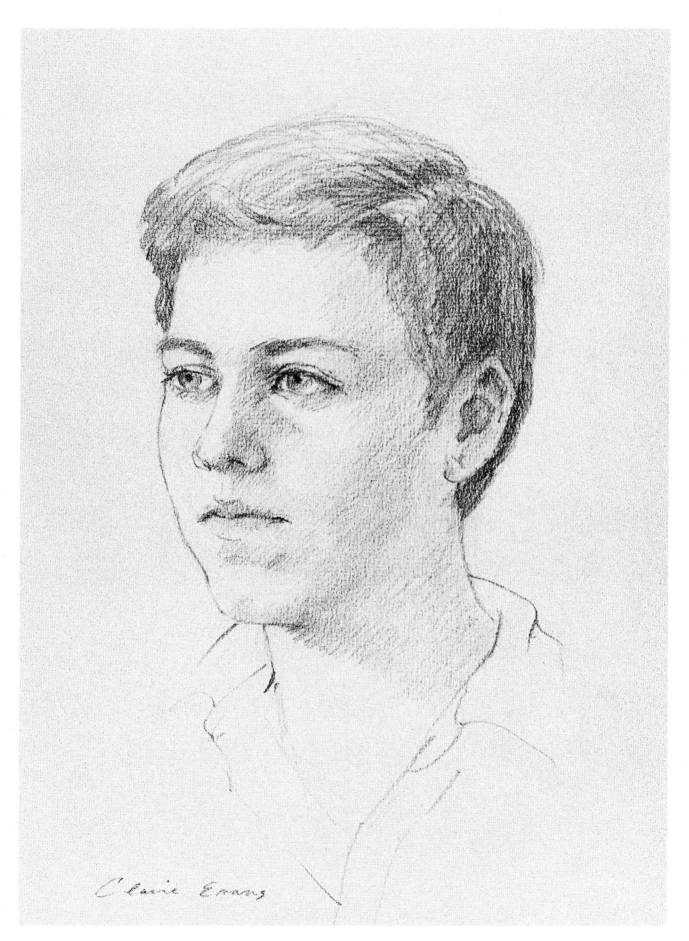

Claire Evans

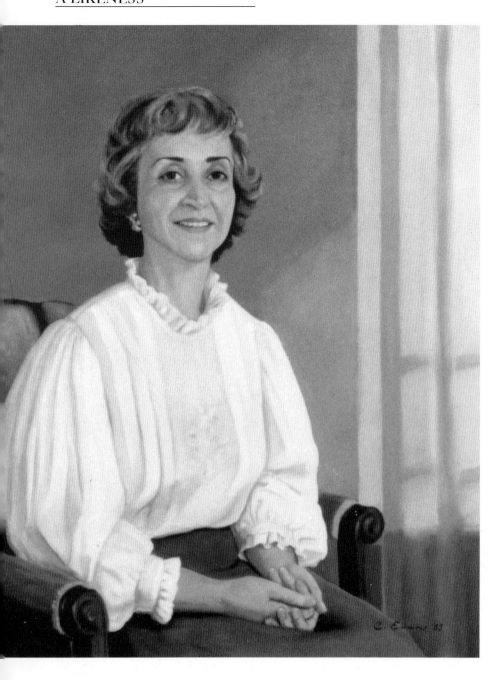

PORTRAIT OF A HUSBAND,
oil on canvas, 32″ × 26″
(78.7 × 66 cm).
PORTRAIT OF A WIFE, oil on
canvas, 30″ × 24″ (76.2 × 61 cm).
*Evans says, "These were commis-
sioned portraits of people I like very
much; so I felt obligated not only to
get a good likeness, but also to show
strong, positive, loving people."*

*Even though the husband is a busi-
nessman by profession, he chose to
be portrayed here in comfortable, ca-
sual clothes. Evans says she tries to
find out how the subject sees himself
and how he wants to be seen by oth-
ers before she begins a portrait.*

*This is the second version of the
wife's portrait. Evans explains, "The
first one is in the dumpster. I picked
the wrong costume and the wrong ex-
pression. She looked simpering, but
she is really someone who is more hi-
larious than just pleasant."*

(above) PORTRAIT OF MATTHEW, oil on canvas,
34″ × 24″ (86.4 × 61 cm).
The artist says this is the way the child looked to her, a very thoughtful little face, very curious about what she was doing. For Matthew's parents, Evans did a very different portrait, one that showed him with a big grin. She points out that the anatomy of children is very different from that of adults. She suggests that if you want to create successful portraits, you should study the anatomy of the human figure at all ages.

(left) PORTRAIT OF A SMILE, pencil on paper, 11″ × 12³/₄″
(27.9 × 32.4 cm).
Evans thinks it is important to be able to draw people of any age. In her study of anatomy she has concentrated on how the body evolves from youth to old age. In this portrait of an older woman note that the facial structure is very different than the young boy's, Matthew. Unlike the child, whose facial features are more rounded and less pronounced, the adult, and especially the aging adult, is characterized by looser flesh and more concave contours. The adult face is often more sculptural, however, owing to the larger, stronger features. The creased flesh, caused by the lack of elasticity in the skin, provides the artist with an opportunity to draw subtle, delicate lines, such as those that appear in the corners of the eyes and mouth.

ASSIGNMENT

Find several photos of faces in magazines or newspapers. The faces must be looking directly at the viewer and not tilted forward or backward; if the head is tilted, it will change the spatial relationship of the facial features.

Put a piece of tracing paper over the photo and draw the outline of the head. Now draw a straight vertical line through the center of the forehead, nose, and chin. Next draw three straight horizontal lines through the center of the eyes, the bottom of the nose, and the middle of the mouth.

Remove the tracings from the photographs and set the tracings next to each other. By comparing the guidelines in each drawing, you can begin to see how the placement of facial features varies from person to person.

COUNTY CONVENTION, ink and colored pencil on paper, 9″ × 12″ (22.9 × 30.5 cm).

These are two pages from Effenberger Thompson's sketchbook in which she recorded impressions from a political convention. Here, she considers all the visual elements in terms of how they will fit into the total design. She uses both people and inanimate objects as repetitive shapes to enhance the composition.

In her sketchbook drawings, Effenberger Thompson records details to be used in later drawings and paintings. Notice that she has captured people's attitudes here even though the figures are so small.

8 DRAWING PEOPLE TOGETHER

Karmen Effenberger Thompson

Drawing groups of figures requires all the basic drawing skills plus the eye of a theatrical director and the balance of a juggler. This is a good description of Karmen Effenberger Thompson, whose drawings of groups always have a strong design impact as well as a sense of the people portrayed.

Effenberger Thompson looks on drawing as problem solving. She sees every piece as having a purpose—to describe a situation, to convey an interpersonal relationship, or merely to create a strong visual impact. Before she starts working, she clarifies in her own mind what the purpose or problem is. Then she works on the drawing, often taking it through several versions, until she has achieved her goal.

SHAPES AND PATTERNS

Effenberger Thompson thinks that the only difference between creating a drawing of one person or twenty-five people is that the main shape is different. She looks on a group of three, five, or fifty figures as one total shape.

An excellent example of this is the drawing *Hiking Club, 1890* (page 121), which she executed as a poster for the Flatiron Philatelic Society. The organization wanted mountains in the background, and the artist decided it would be fun to compose the figures as another mountainlike shape, thus making the people a part of the landscape.

Much of Effenberger Thompson's work is commissioned, so she often has to work to other people's directions. In this case the organization specified a group of people in turn-of-the-century costumes based on historical photographs of hiking groups, with a rendering of The Flatirons, a specific Colorado rock formation, in the background. She met their demands and her own in this well-designed piece.

Another design concept that Effenberger Thompson uses to help organize her drawings of groups is patterning. She says she thinks of the human figures as basic shapes, and she arranges those shapes in interesting patterns.

County Convention (page 110) is a two-page study taken from the artist's sketchbook. She began the drawing with the speaker on the podium, then worked into the general patterns of figures and architecture. The bodies, the placards, the stairs, the flags—she used all of these as abstract shapes in developing the total patterns.

In all Effenberger Thompson's work she is very concerned with space. Sometimes she arranges the figures in receding planes in order to create a feeling of three-dimensional space. In other drawings she assigns arbitrary shapes and sizes to the figures, keeping them all on the surface level. In every piece, however, she is very concerned with the relationships of positive and negative space, using both elements to define the figures and develop the patterns.

INTERPERSONAL RELATIONSHIPS

In many of Effenberger Thompson's pieces the most significant aspect is the relationship between figures—who is doing what to whom. She conveys these attitudes with facial expression, gesture of the body, and relative placement.

Many of the drawings that she has done for the Denver Center Theater Company are illustrations of particular plays or particular performances. The key to the play is often characterization; consequently, that becomes the focus of the drawing, personalities in conflict or harmony.

In *Cyrano* (page 116), for instance, she conveys the basis of the entire plot in one simple drawing. Cyrano, the main figure, has engineered a romance between the two lovers shown in the drawing. He

actually loves the woman himself but believes she could never love him because of his abominable nose. Thus, the drawing reveals a basic love triangle, emphasized by the triangular placement of the figures; however, Cyrano remains separated by the textural division of the background.

Notice how the artist has used shape in an arbitrary way in *Cyrano*. Even though she is primarily concerned with characterization, she never loses her feeling for dramatic, innovative design. She says, "I like to create shapes on the page that are unexpected. The immediate effect is one of shape, and the details come out later as the viewer reads the page."

WHAT DOES THE PICTURE MEAN?

Sometimes the drawing has an idea or statement beyond basic characterization. *Mailbox Magic* (page 118) expresses an idea Effenberger Thompson developed for an exhibit on fantasy. She put three unrelated ideas together to create one image. She used the pedestrian, everyday image of the mailbox as a background primarily for its color and shape. Then she added one of the hang-gliders that are a common sight in Boulder, Colorado, where she lives. She completed the concept with an audience of turn-of-the-century spectators.

All the elements in *Mailbox Magic* are united by design. The spectators across the bottom of the format and the glider in the upper center form a triangular shape. And if you look at the central figure, his direction of flight brings your eye downward to the crowd; then their direction of attention takes you back up to the gliding figure.

LEARNING TO SIMPLIFY

Effenberger Thompson says, "The hardest thing about drawing groups is knowing what to put in and what to leave out. I work from general to specific. When I start, I'm not thinking hands, feet, faces. I am thinking of larger forms rather than details. The details come later.

A case in point is her painting *Weekday at the Reservoir* (page 114). Here, Effenberger Thompson wanted to capture the variety and activity of people on a beach. She tried recording the entire scene in an on-the-spot watercolor. She realized quickly that there was too much going on to put it all immediately into a drawing, so she picked out the most interesting individuals and groups and drew those in her sketchbook. She looked for interesting character, physical appearance, stance, and clothing. She drew small vignettes of these figures and later combined them into a finished composition.

SKETCHBOOK PAGES
These pages from Effenberger Thompson's sketchbook are studies she made at Boulder reservoir for future paintings of people on the beach. She is concerned primarily with the shapes and gestures of individuals and with the shapes of groups. Notice the triangular shape created by the figure on the lifeguard stand and the two figures seated below it, or look at the flowerlike shape of the figure holding the umbrella. In both cases, Effenberger Thompson is more concerned with the general shape created by the figures than with the anatomical details of the figure.

Effenberger Thompson rarely works from photographs; so she must record in her sketches all of the information she will need for future paintings.

(above) WEEKDAY AT THE RESERVOIR, mixed water media, 22″ × 30″ (55.9 × 76.2 cm).
Effenberger Thompson did the research for this painting by visiting the Boulder reservoir and making numerous sketches of the scene in her sketchbook. The composition of the piece was designed as bands of color with all the figures placed in just one band across the center. The artist was also concerned with the light on the beach because in this very bright light the figures become impressionistic shapes without specific contours.

(top right) DETAIL
In the close-up, you can see that the artist clearly draws her inspiration from her initial beach sketches. The arrangement and gestures of the group seen in the sketch below reappear in the detail of painting above.

(bottom right) SKETCHBOOK PAGE
In Effenberger Thompson's sketches, she is concerned with shape, gesture, and the relationship between people. Notice how she records the tilt of the head and the angle of the spine. These gestural details are what give her finished drawings and paintings their vitality.

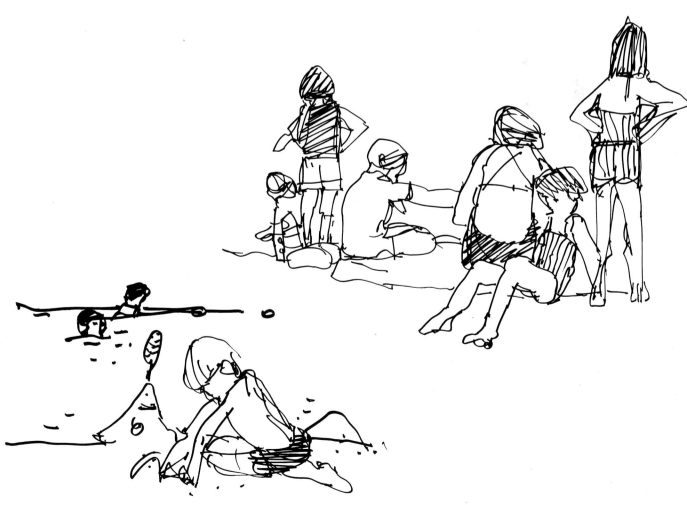

CYRANO, ink and colored pencil, 12″ × 10″
(30.5 × 25.4 cm).

In this simple theatrical drawing, Effenberger Thompson conveys the substance of the entire plot of the play. Cyrano has engineered the romance between the lovers on the left. Cyrano is also in love with the young woman, but believes she could not love him because of his appearance. This romantic triangle is conveyed by the placement of the three figures in a triangular composition.

ROMEO AND JULIET, ink and colored pencil, 12″ × 7″
(30.5 × 17.8 cm).

This is a drawing commissioned for the Denver Center Theater Company. As in Cyrano, Effenberger Thompson focuses on the relationship between the main characters in a play. She explains that she drew Romeo and Juliet in profile, looking slightly away from each other because she didn't want the drawing to be too romantic. She says, "I think young people are probably more self-focused. The devoted love only comes after fifty years of living together."

TWO LADIES, ink and colored pencil, 9″ × 8″
(22.9 × 20.3 cm).
*Here the artist was drawing female characters from two very
different plays,* The Importance of Being Earnest *and* Romeo
and Juliet. *She separates the women by making them look
away from each other; but she unites the figures with
proximity and with the S-curve created by their arms running
together.*

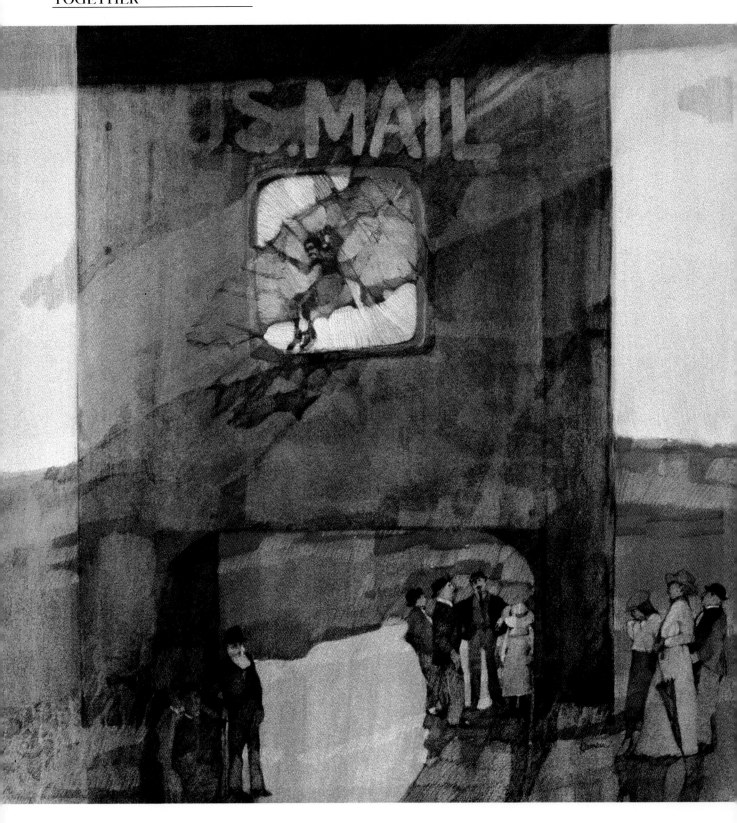

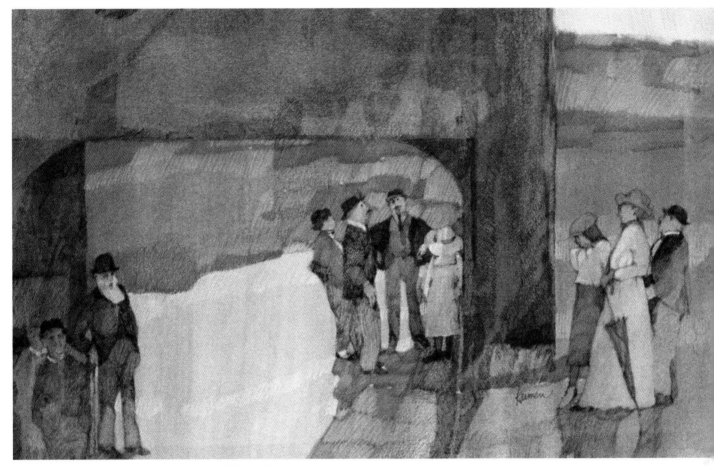

(left) MAILBOX MAGIC, mixed media, 21″ × 21″
(53.3 × 53.3 cm).
Effenberger Thompson likes to play with the positive and negative space of her compositions. In this piece, even though the figures are the focus, they are smaller than the negative space, which she had divided into large, interesting patterns. Notice the placement of the figures as three points of a triangle. This helps provide a sense of balance for the total composition. It also adds to the movement within the piece because the viewer's eye continues to move from one point of the triangle to another.

(above) DETAIL
Here you can see how the artist arranged the spectators in small groups of figures. With each group she is concerned about a complete design, making sure that the shape of each figure adds to the composition of the group. Notice the interesting shapes she achieves in the negative space with the placement of the men's legs.

(top left) POMP AND CIRCUMSTANCE, ink on paper, 9″ × 13″ (22.9 × 33 cm).
This drawing is a scene from Shake-speare's Much Ado About Nothing. *With many of her theatrical drawings, the artist works from her imagination; however, this one was done during a dress rehearsal. As in all of her theatrical drawings, Effenberger Thompson's concern is to portray the individual character of each figure by concentrating on their personality, costume, and relationship to other figures.*

(bottom left) BLOOMERS, colored pencil on paper, 7″ × 10″ (17.9 × 25.4 cm).
In her illustration of old-fashioned women cyclists, the artist focused on the legs and bloomers because the bloomers were considered so risqué at that time. Notice how she creates interesting patterns with the shapes of the bloomers. Effenberger Thompson looks at all the components of a drawing as abstract shapes to be arranged into the most interesting design.

(right) HIKING CLUB, 1890, poster, 13″ × 10″ (33 × 25.4 cm).
This commissioned drawing of a turn-of-the-century hiking group was based on historical photographs. Notice how Effenberger Thompson placed the figures in a triangular-shaped group that corresponds with the shapes of the mountains in the background. Again, the artist stresses that when working with groups, it is important to look at the shape of the total group.

DESERT ROAD, watercolor on paper, 22″ × 30″
(55.9 × 76.2 cm).
*This painting illustrates Dulaney's technique of taking the
figures from her preliminary drawings and combining them
with the elements of landscape to create vital compositions.
Here, she breaks up the landscape images in order to create
more movement; Then she stabilizes the painting a bit by
including parallel a series of horizontal lines in the dancers
and the surrounding landscape forms.*

9 FIGURES IN MOTION

Shawn Dulaney

It is understandable that Shawn Dulaney would want to draw figures in motion—she has been a dancer since she was eight years old. She says she looks at the whole world in terms of movement and is constantly noticing the way people move rather than the way they look. Dulaney also thinks that moving gestures reveal more about people than their features do. Using her knowledge as a dancer and as an artist, Dulaney has become adept at drawing the illusion of motion.

"The first step in portraying movement is understanding it," Dulaney says. "By studying anatomy you can understand it in your mind, knowing what the muscles and bones are doing when you are moving across the floor."

Dulaney has become more and more concerned with anatomy because knowledge of anatomy adds strength and substance to the gestures she is seeing. "Observing anatomy in dancing classes is especially helpful," Dulaney says. "How do the muscles change during a movement? What muscles are holding the dancer up during that movement?"

However, Dulaney feels that it is even more important to understand movement in your own body than comprehending it in your mind. Ask yourself what it feels like when you walk, run, spin, or jump? If you don't know these feelings, Dulaney says, you cannot express them on paper.

She describes the drawing process as such: "I see a movement. Then I think out the feeling of that movement. I try to visualize it, and then draw it fast. Of course, all of this is fast, faster than it takes to talk about it. I'm not thinking when I'm drawing; I think it out first.

"Sometimes when I can't get a drawing to work, I get up and do the movement myself. I try to get the feeling rather than look in the mirror. I think anybody can learn to feel movement because we all move. Even though dance is movement, most paintings of dancers seem to have nothing to do with motion. When you look at them, you know the artist never ran across a floor."

DRAWING THE MOVING FIGURE

Dulaney generally works with one moving dancer as her model. She draws with a stick of graphite on a long roll of paper on the floor, trying for a continuous sequence of gesture drawings that shows the flow of movement. She wants to know what the figure looks like as it is coming from somewhere and going to somewhere else.

She works fast and big, using as much of her own body as possible. It is nearly impossible to convey motion when you are sitting in a chair, drawing tiny figures with only your fingers and wrist. When you use your whole arm and shoulder to draw, the looseness of your body will create a more fluid line that reads as motion.

The line quality is very important when you set out to capture motion. Dulaney draws a loose contour line, deliberately changing the pressure and breaking the line. She says her eye is encompassing the entire figure, but jumping to the one or two points that best show the gesture. She will also emphasize or exaggerate parts of the figure that best convey the motion. She usually starts with the head or hands or with one center line down the body. As with any gesture drawing, Dulaney is looking at the large shape of the total body.

DRAWING ON A ROLL OF PAPER

Dulaney draws on a roll of paper for several reasons. She says, "The roll gives me momentum; I don't have to stop and change the page. Afterwards I can see the whole sequence of movement."

The model moves through a dance sequence stopping for twenty to thirty seconds whenever the dancer thinks it is a good pose or when the artist says to stop. To capture a jump or spin, Dulaney has the dancer repeat it several times. She says that after a while twenty to thirty seconds seems like a long time to capture movement.

The examples shown in this section are Dulaney's drawings of two different dancers. These drawings are the result of teamwork between artist and dancer, so she chooses her dancers carefully. "People are made up of their gestures," she comments. "I can't work with a dancer if we don't have rapport. Their movements reflect their personalities."

The two dancers you see here are Bill Douglas and Isabelle Depelteau. Dulaney says the drawings differ as the dancers differ. Bill has more angular movements; they are also more intellectual, reflecting the choreography of Merce Cunningham, with whom Bill studies. Bill is very refined and precise in his motion.

Isabelle's movement is more intuitive. It is also different from Bill's because Isabelle is a large person, and size has a definite effect on movement. She is tall with broad shoulders, and she uses that size as an advantage to give her dancing power and presence.

Dulaney considers these gestural drawings as working drawings, not finished pieces of art. They are a good resource that she can refer back to for basic shapes and positions.

REFINING THE DRAWING

The second stage of drawings is done on separate sheets of paper or in Dulaney's sketchbook. These are more refined drawings taken from the first sketches done on rolls. Notice that the drawings of Bill (pages 130-132) are done with an electric, almost jagged line that shows the angularity of his movement.

Dulaney's concern here is to eliminate all but the most important lines. She tries to maintain the spontaneity of the first sketches, but to make them more solid.

In the drawings with repeated figures (page 132), she uses the repetition to intensify the illusion of movement.

In the sketchbook drawings of Isabelle (pages 133-135), Dulaney is also working from basic gesture drawings. Here she takes the original movements and re-draws them in combination with watercolor washes, which gives a solidity to the figures.

In these secondary drawings, Dulaney is designing groups of figures on the page and has become very sensitive to the patterns of negative space.

THE FINAL DRAWINGS

In the final stage of her drawings (pages 125-127), Dulaney takes the shapes of her moving figures and combines them with the shapes and colors of the landscapes of the Southwest. She uses this terrain because she thinks that the basic forms found there convey a natural sense of movement.

In some pieces Dulaney uses the patterns of the landscape in the costumes of the dancers, while in others she colors the figures and background with the elements of landscape. She says that fragmenting the images gives an increased sense of movement, like looking through the window of a moving car.

(top right) APPROACHING STORM, watercolor on paper, 15" × 22" (38.1 × 55.9 cm).
Here Dulaney incorporates the elements of landscape into the costumes of the figures, and leaves the negative space simple to provide contrast. Notice that the colorful scarves that the dancers are holding flow from one dancer to the other, adding more motion within the painting. In this painting Dulaney has developed the facial features and hair more than in her preliminary sketches, but they are still minimal. In Dulaney's work the personality of the individual figures is always less important than the movement.

(bottom right) DELICATE ARCH, watercolor on paper, 22" × 30" (55.9 × 76.2 cm).
This is an example of the southwestern landscapes Dulaney uses to add to her dancing figures. She incorporates these exotic landscapes into her work because the shapes she sees there—the cloud and mesa formations—have an inherent feeling of motion.

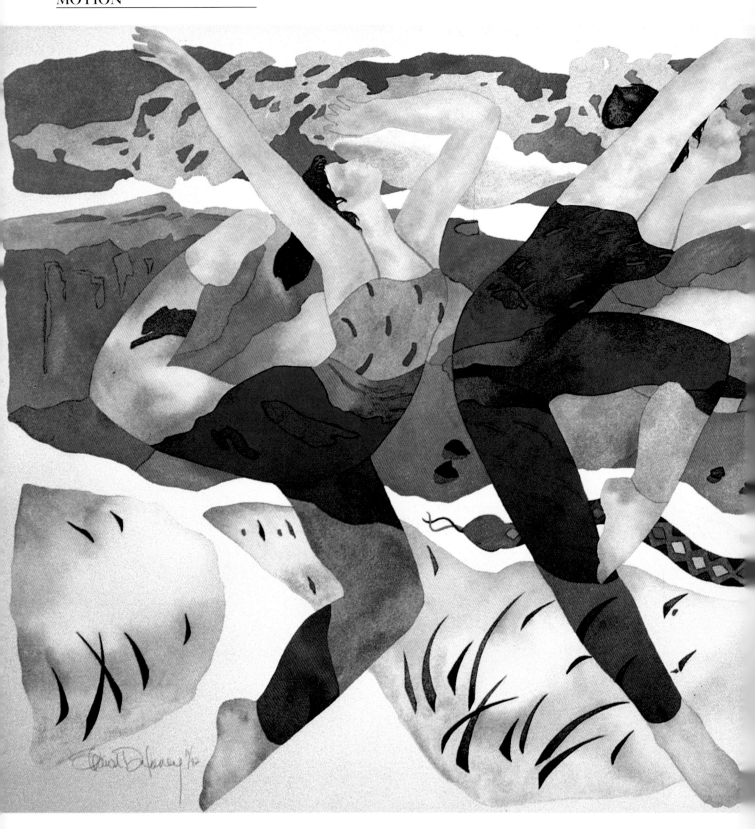

MESA VIEW, watercolor on paper, 15″ × 22″ (38.1 × 55.9 cm).
This landscape shows us the shapes, colors, and patterns that Dulaney interweaves with her dancing figures in order to create movement. When Dulaney paints landscapes without figures, she looks for scenes that have a strong sense of motion in their basic patterns. Then, by adding these rhythmic elements to her dancers, she creates figures that appear to be moving.

ROAD TO CHIMAYO, watercolor on paper, 22″ × 30″ (55.9 × 76.2 cm).
This is a particularly vital painting. The poses of the dancers convey a strong sense of movement that has been stopped in midair. The elements of landscape also convey movement: the clouds, the snake, the grasses bent over in the wind. Notice that the dancing figures move in and out of the background because of the overlapping of landscape elements.

FIGURES IN
MOTION

PRELIMINARY DRAWINGS:
ISABELLE AND BILL

*In her preliminary drawings of
dancers, Dulaney works with one
dancer as a model. She has the sub-
ject pass through a series of dance
movements while she makes very fast
sketches on a roll of drawing paper
spread out on the floor. This paper is
thirty-six inches wide and several
yards long; and it is heavy enough so
that she can actually crawl on it with-
out tearing it.*

*Dulaney draws up to three dance
movements in a row before she unrolls
the paper to the next clean drawing
space. Working on the rolls of paper
allows Dulaney to move quickly from
one drawing to the next, without inter-
rupting the flow of movement by
changing sheets of paper.*

*These gesture drawings are exe-
cuted with fast, loose, flowing lines.
Dulaney is concerned with capturing
the shape and lines of the movement;
so she draws only the anatomical fea-
tures that express the position of the
body. If the legs are especially impor-
tant, as in a jump, she will emphasize
the legs. In a contraction, where the
whole body is curled up, Dulaney will
focus on the curve of the spine. Rarely
is the face indicated by more than the
simplest suggestion of features.*

*Dulaney is especially concerned
with showing the thrust of movement
and the balance of weight. If there is
an important bend or twist to the body,
that will be stressed.*

*One of the biggest differences in the
drawings of Isabelle and Bill is caused
by costume. Isabelle is wearing a
skirt; the drawings of her show the
shape and movement of the fabric. Bill
is in tights; the drawings of him have
more of the feeling of underlying
anatomy.*

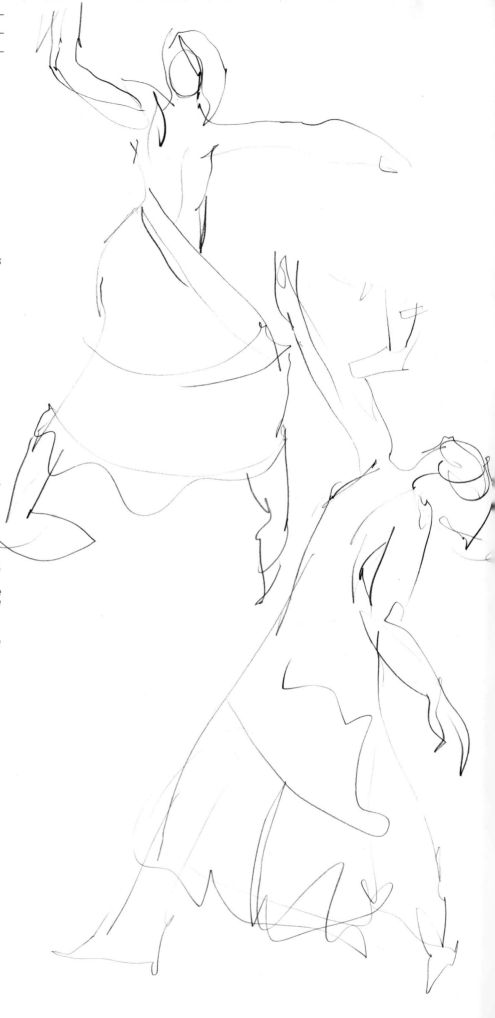

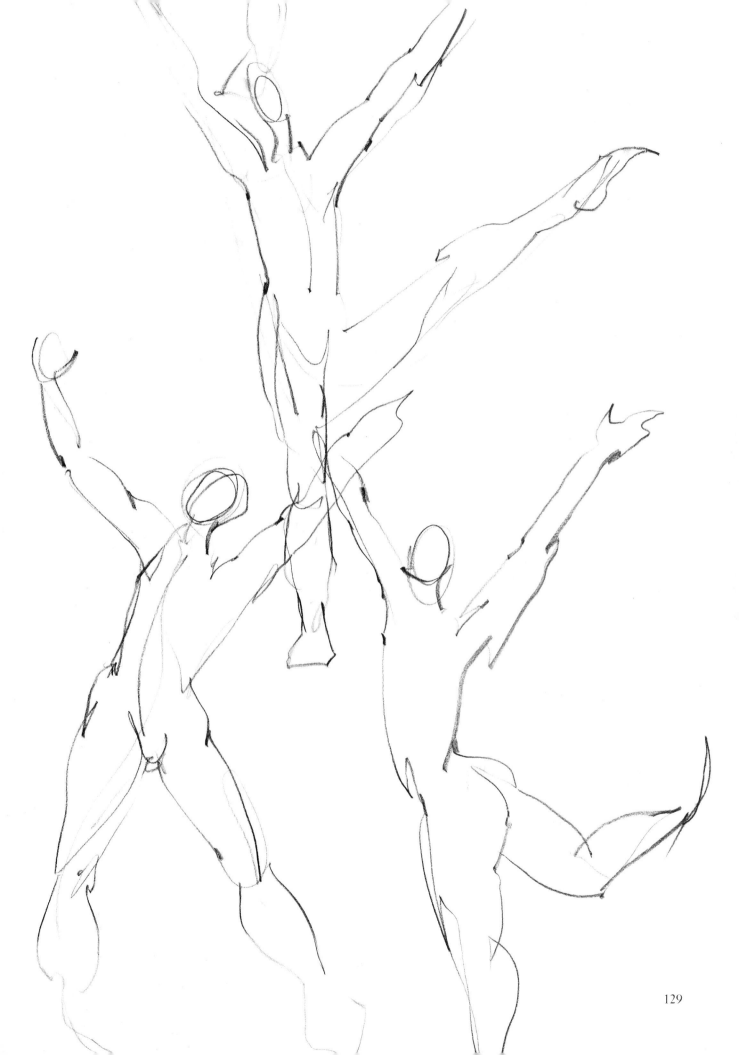

129

SECONDARY DRAWINGS: BILL

In these secondary drawings, executed in pencil, Dulaney is working from her gesture drawings rather than from the model. She is concerned here with refining the expression of the dancer's movement.

1. *The main gesture of this pose is a long, straight diagonal from lower right to upper left. What keeps the viewer's eye from following the diagonal right off the page is the curved arm and the head bent backwards. Notice also the strong masculine feeling of the lines.*

2. *This is a relatively simple drawing that is concerned with balance. The figure appears to be resting on one leg. The torso is tilted with the arms extended to provide balance. Dulaney is not drawing specific anatomical details, but her knowledge of anatomy is implicit in the placement and relationships of parts of the body.*

3. *The thrust of this movement is the sideways bend in the body. In this drawing Dulaney emphasizes the gesture by cropping the lower part of the figure. The delicate, graceful lines make the movement itself appear more graceful.*

4. *The focus of this gesture is the arch of the torso. The right side of Bill's body is extended and the left side is folded back on itself. Notice the vital line quality—the broken lines; the lines that flow from thick to thin and from light to dark; and the lines that dramatically change direction in sharp angles.*

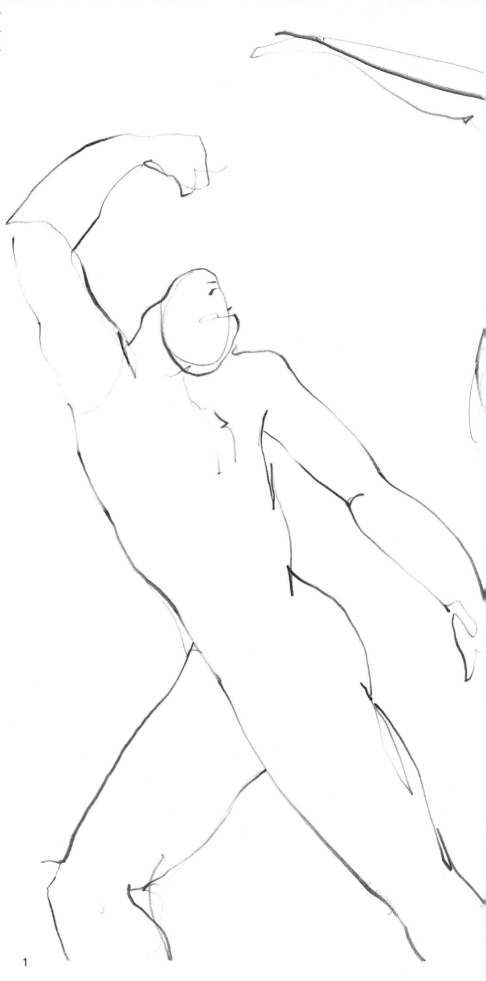

1

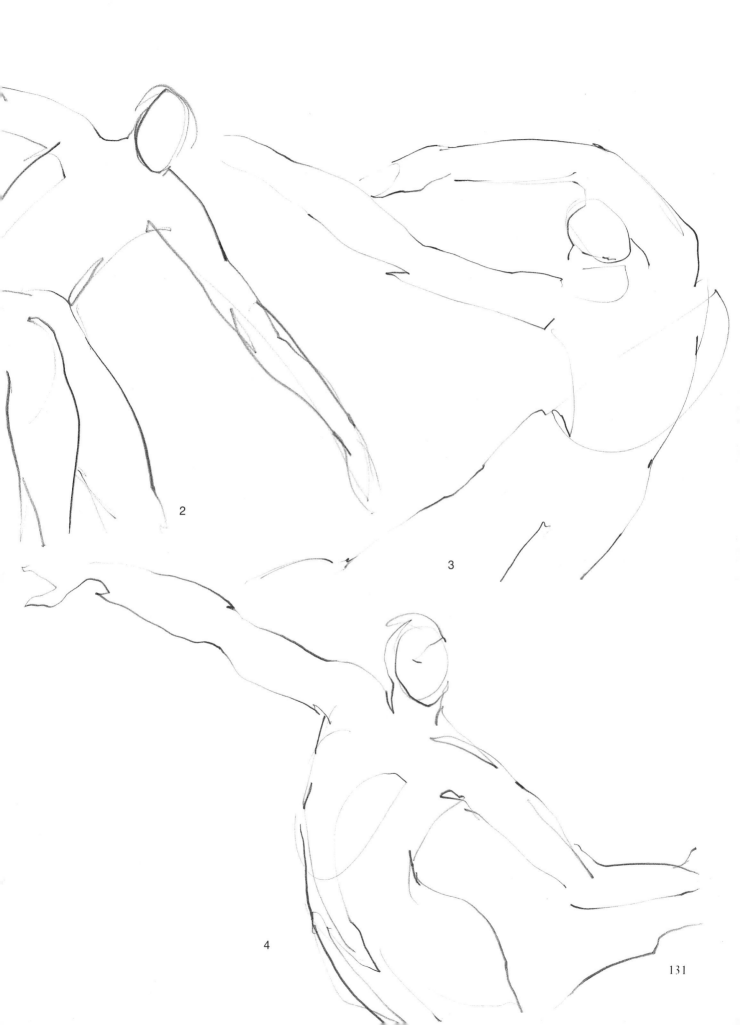

2

3

4

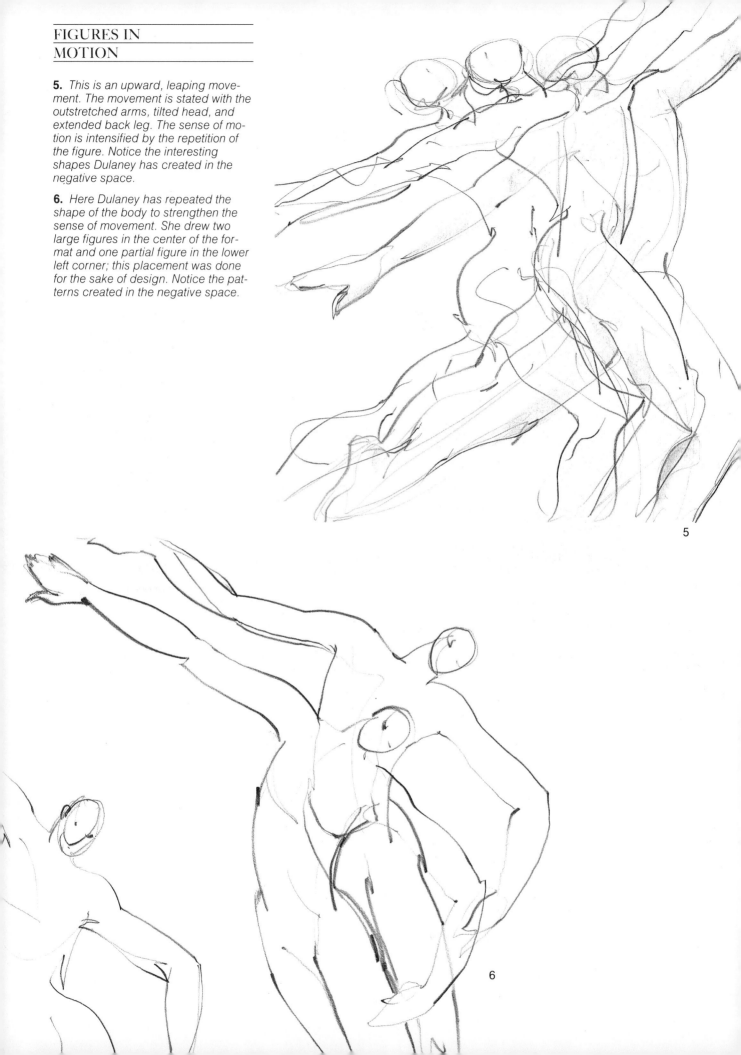

5. *This is an upward, leaping move-ment. The movement is stated with the outstretched arms, tilted head, and extended back leg. The sense of mo-tion is intensified by the repetition of the figure. Notice the interesting shapes Dulaney has created in the negative space.*

6. *Here Dulaney has repeated the shape of the body to strengthen the sense of movement. She drew two large figures in the center of the for-mat and one partial figure in the lower left corner; this placement was done for the sake of design. Notice the pat-terns created in the negative space.*

5

6

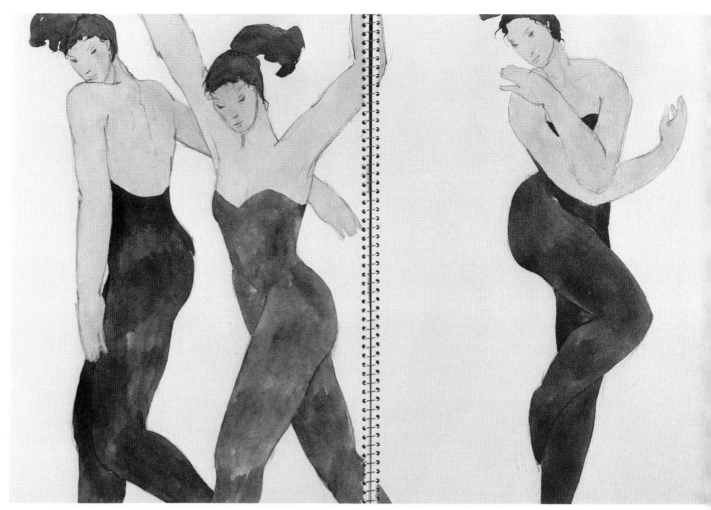

SECONDARY DRAWINGS: ISABELLE
In these sketchbook drawings Dulaney is reworking basic gesture studies of Isabelle. Her primary concern is to combine several figures into one composition that will create strong design and convey the movement of the dancer. She creates simple contour drawings with pencil, then enhances them with watercolor washes.

1. *These are three consecutive poses of one movement. Dulaney places two figures together and one alone for design. She thinks that when one figure is very strong, putting another figure with it will detract from its strength. In other cases, grouping two or more figures will give each of them more power. Notice how she extends the central figure across the divider; this helps to unite the two pages.*

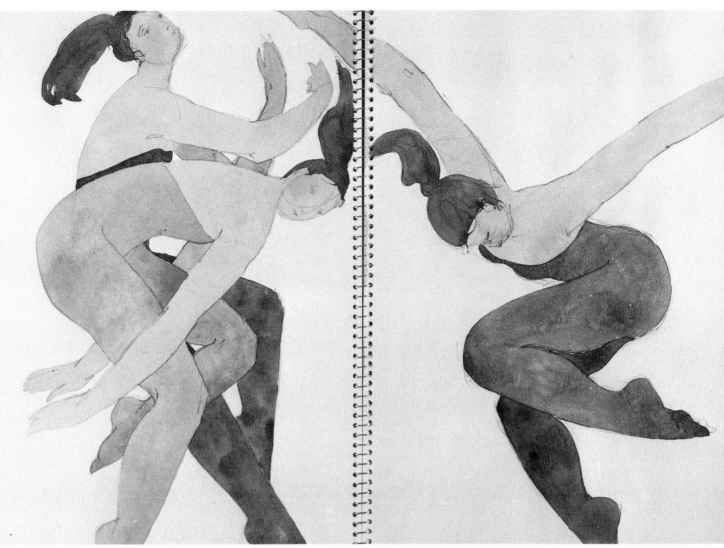

2. *Dulaney says that each of her sessions with a dancer has a particular mood or feeling. She says that this session with Isabelle was one of high energy. The dancer did repeated leaping movements that expressed the feeling of flight. In this drawing Dulaney was most concerned with projecting that feeling of the dancer's flying.*

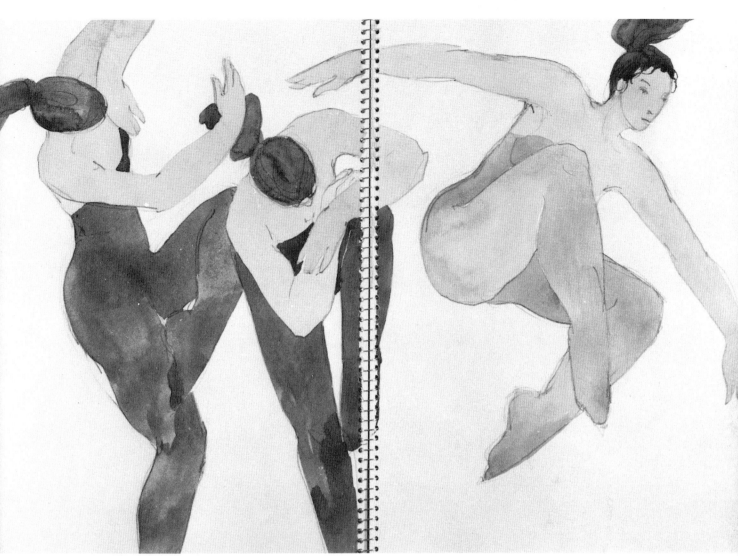

3. *This is another of the flying series. In this sequence the dancer is rolling down and then flying into the air. Notice the point of view in this drawing. We are below the dancer, looking up. This reinforces our feeling of the dancer being in the air.*

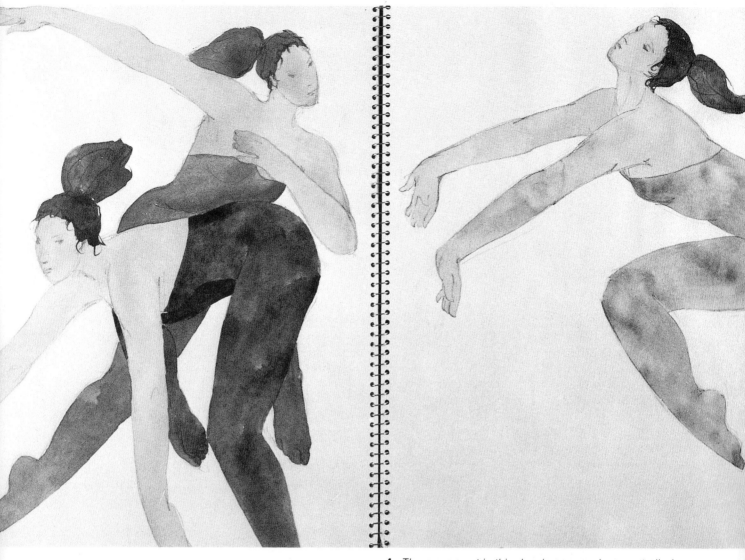

4. The movement in this drawing seems less controlled, almost chaotic. Notice how Dulaney crops the figures rather than using the total body. The overlaid figures on the left also give us the sense of fragmentation that implies activity. Notice that the figure on the right is reaching out to the other figures. Even though the dancer on the right is divided by space from the two dancers on the left, her gesture unifies the figures and brings a feeling of order to the total composition.

10 CONCLUSION

In this book I have tried to show you the vast scope of figure drawing. From the quick line drawings of Bob Ragland to the rich pastels of Doug Dawson, we have looked at the drawing of people as a discipline, an exploration, and a joy.

I chose to include renderings of the figure in all media so that you could see how the basic elements of figure drawing are vital to all figure work. Whether you draw in ink or pastel, the subtleties of value and the vitality of line enhance your finished work. Whether you paint in watercolor or oil, the composition of the piece, the gesture of the figures, and the total expression are all vital.

I believe that anyone can learn to draw people. Certainly there are artists with a natural eye-hand coordination that makes drawing easier, but even the beginner who "can't draw a straight line" can master the art of figure drawing. In the life drawing classes I have taught, I have seen novices who had never drawn a model before, but who had a tremendous desire to learn. These students began slowly and with much frustration; however, during even one school quarter their drawings took on a strength and sensitivity that was marvelous to see. What caused this wonderful improvement? Even more than a natural ability, it was their desire to learn and their willingness to practice.

Even when a student is taking several studio courses a week where he or she is drawing from a live model, I still insist on a sketchbook. I demand that my students draw outside of class because I want sensitive observation and drawing to become a part of their lives. Drawing skills, even for the most talented artist, come only with hours and hours of practice.

There are several characteristics common to the artists in this book and to all artists who create beautiful figure drawings:
1. They have a love of people.
2. They are interested in drawing technique.
3. They share a desire to explore what they don't know.
4. They have the discipline to practice, practice, practice.

Figure drawing is a means of expression. The artist conveys mood, personality, and place in his drawing of a person. It is a way of achieving self-understanding. It is a way of recording history. Figure drawing is an escape and a challenge, but, most important, figure drawing is fun.

Perhaps the most valuable thing I can tell you is to enjoy drawing. Let yourself be passionately involved with the act of drawing. It is this delight and passion that will bring your drawings to life.

THE GALLERY
OF ARTISTS

MEL CARTER

Mel Carter has studied art around the world. He received his Master of Fine Arts degree in Guanajuato, Mexico; and has done graduate study in Italy, the Soviet Union, and Norway. He teaches at The Community College of Denver, but has also taught at the University of Rome; the Sorbonne, Paris; and University College, London.

BOB THOMAS

Bob Thomas's art education includes a fine arts degree from the John Herron School of Art at Indiana University and a Master of Fine Arts from the University of Denver. He has taught at the University of Denver, Loretto Heights College, and Rocky Mountain College of Art and Design. In addition to his figure drawings, Thomas enjoys painting non-objective oils and pastels. His work has been exhibited from Indiana to California.

BOB RAGLAND

Bob Ragland is known as a television personality and lecturer as well as an artist in the Denver area. Outside Colorado, his art has been shown in La Jolla, California; Taos, New Mexico; Corpus Christi, Texas; Cleveland, Ohio; and Seattle, Washington.

KIM ENGLISH

Kim English studied art at Rocky Mountain College of Art and Design, where he currently teaches drawing and anatomy. He exhibits his work primarily in the Colorado area.

CAROLE KATCHEN

Carole Katchen received her undergraduate degree from the University of Colorado at Boulder. She has studied art at Bazalel Institute of Art, Jerusalem; Morley College, London; and the Camden Art Center, London. Katchen lives in Denver and exhibits her work in gallery and museum shows throughout the Southwest. She is also the author of two children's books, which she illustrated. Her work has been featured in several magazines, including *American Artist* and *Today's Art and Graphics*.

DOUG DAWSON

Doug Dawson is nationally known for his rich, intense pastel paintings of people and landscapes. He has won the Best of Show Award at the Pastel Society of America as well as awards from the American Watercolor Society, the National Association of Western Artists, and the Pastel Society of the Southwest. Dawson sells his work through galleries and directly to collectors throughout the United States. He also devotes one day a week teaching at the Colorado Institute of Art.

CLAIRE EVANS

Claire Evans studied at Converse College, Spartanburg, South Carolina; the High Museum School of Art, Atlanta; and the University of Colorado at Boulder and Denver. Her works are included in the collections of Amoco Productions, Petrolewis Corporation, Richfield Oil Company, the State of Colorado, and the United Bank of Denver.

KARMEN EFFENBERGER THOMPSON

Much of Karmen Effenberger Thompson's work is commissioned. She has done work for the National Bureau of Standards, the United States Post Office Philatelic Center, The Johns Manville Corporation, and the Denver Theater Company. Exhibitions of her art have been shown primarily in Colorado and Washington.

SHAWN DULANEY

Shawn Dulaney is a young artist who has studied at the New School of Art in Toronto; the Berkshire College of Art and Stratford Overseas Study Center in England; and Mills College in Oakland, California. She has exhibited in juried and solo shows in Toronto, Denver, and New York City, including those at the Katonah Gallery and Warburton Gallery in the New York City area, and at the annual exhibits of the American Watercolor Society and Allied Artists of America.

INDEX

Edited by Candace Raney
Graphic production by Ellen Greene
Text set in 11-point Janson